CALIFORNIA
THEN AND NOW®
People and Places

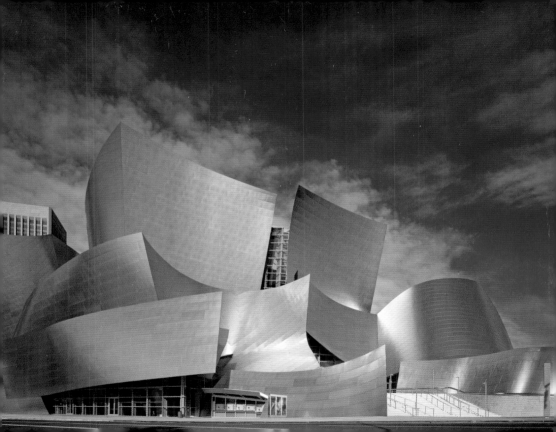

CALIFORNIA

THEN AND NOW®
People and Places

Karl Mondon

First published in the United Kingdom in 2013 by
PAVILION BOOKS
43 Great Ormond Street,
London WC1N 3HZ

© Pavilion Books, 2013

Reprinted 2014 (twice), 2018

Project Manager: Frank Hopkinson

ISBN: 978-1-86205-994-8

A CIP catalogue record for this book is available from the British Library.

Printed by 1010 Printing International Limited, China.

SAN FRANCISCO
page 8

LOS ANGELES
RIVERSIDE
SANTA BARBARA
page 174

CATALINA ISLAND
page 322

SAN DIEGO
page 350

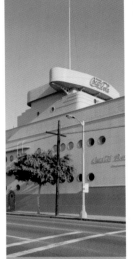

Then and Now – it's a much-loved concept, used to show how a location has changed over the years. In some cases a span of 100 years can show very little change to the scene; Mission Alcala near San Diego has had a coat of paint and more flowers, but little else is different a century later. With Cliff House in San Francisco there have been five distinct buildings over the years, all of which we feature in this book.

But whereas a conventional 'Then and Now' shows you a 'Then' followed by a 'Now,' *California Then and Now – People and Places* mixes up the format, sometimes showing a number of different 'Thens' and a single 'Now,' sometimes showing a single 'Then' and multiple 'Nows.' This allows the reader to see aspects of a historic location that are impossible to replicate today, often through the growth of trees, or the addition of new buildings to the old.

San Francisco-based photographer Karl Mondon tracked down the old locations and even went up in a helicopter to get some key images for the book which highlights the very best of California's great cities.

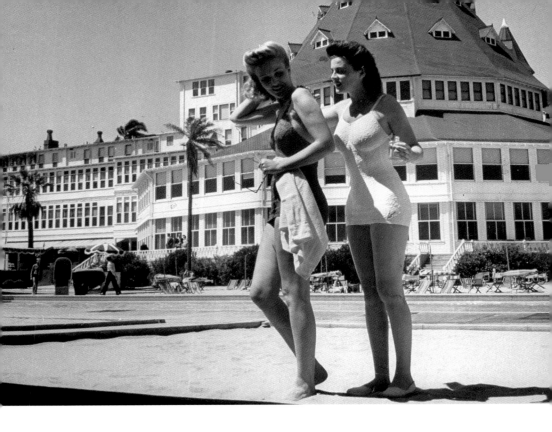

SAN
FRAN

CISCO

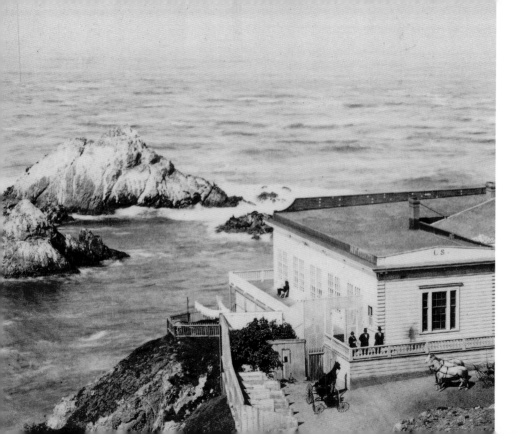

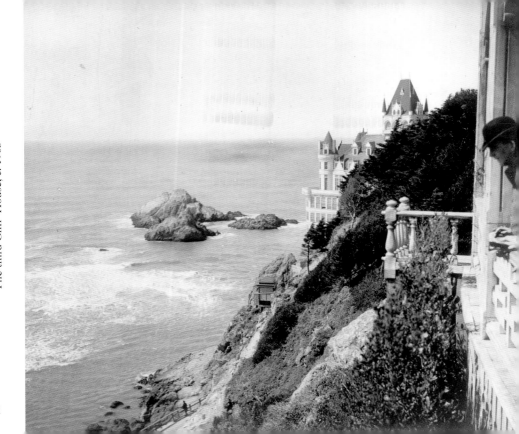

The third Cliff House, c. 1905

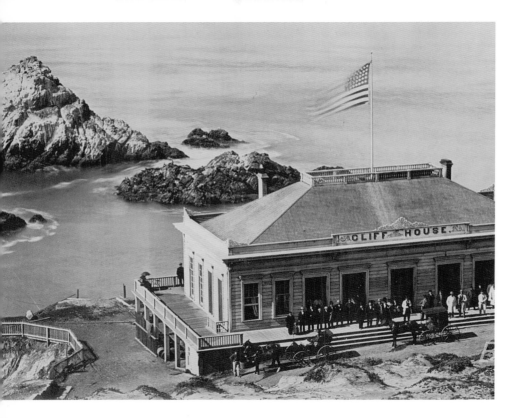

The enlarged first Cliff House, c. 1877

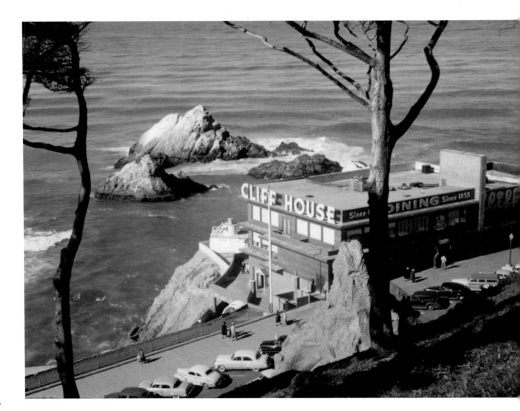

The fourth Cliff House, c. 1956

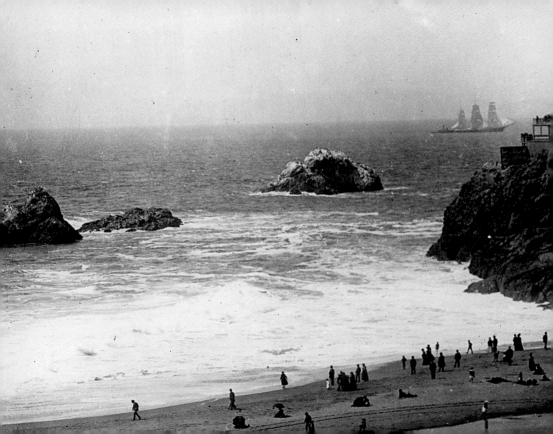

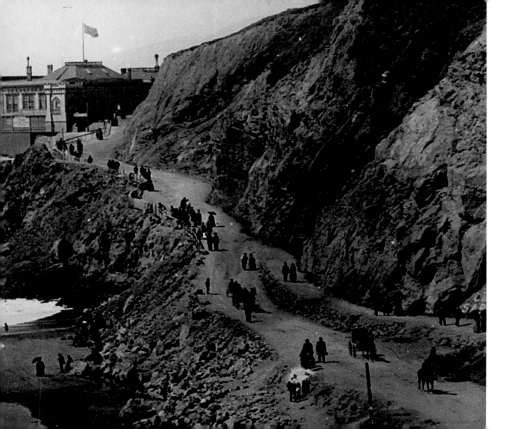

The second Cliff House, c. 1880

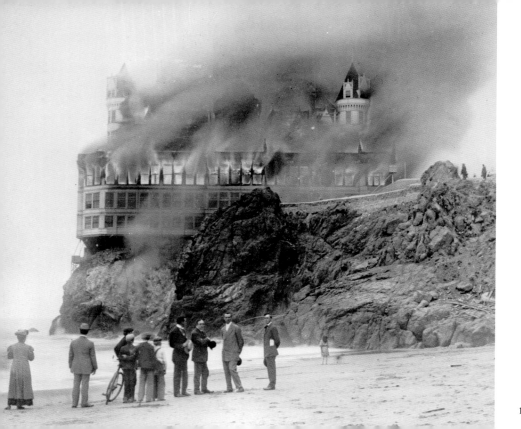

The third Cliff House ablaze, September 1, 1907

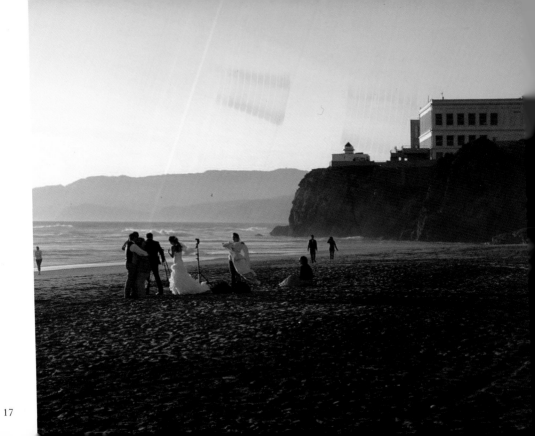

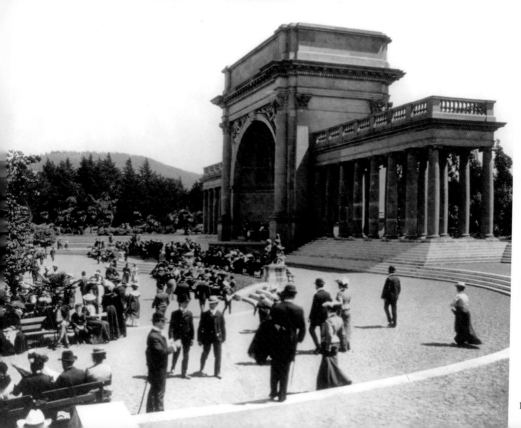

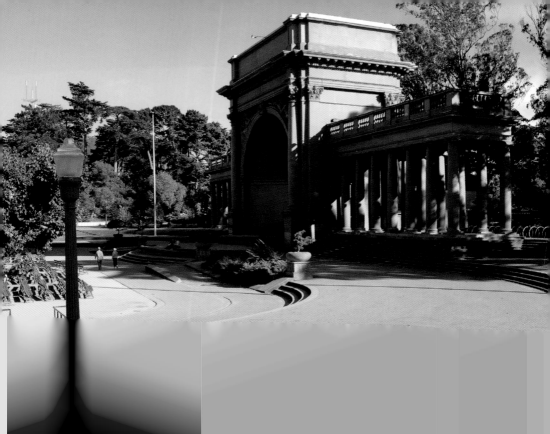

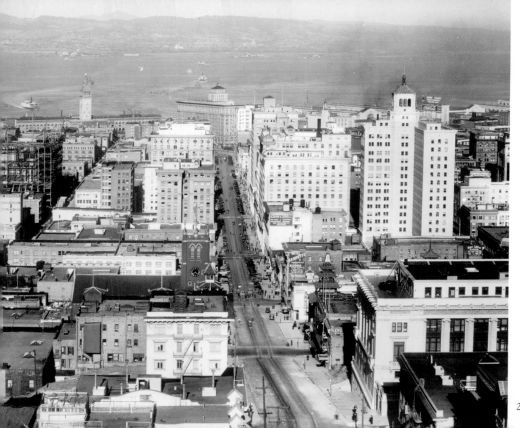

California Street, April 28, 1922

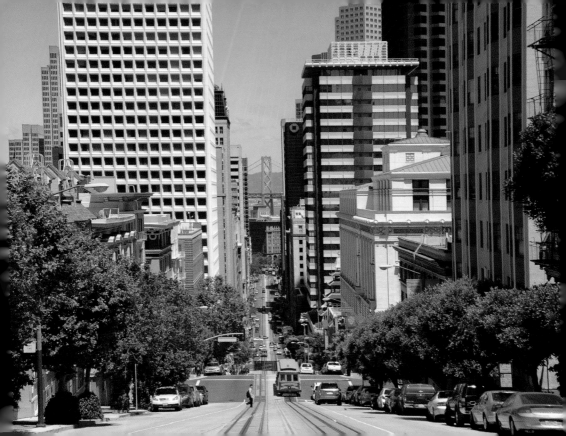

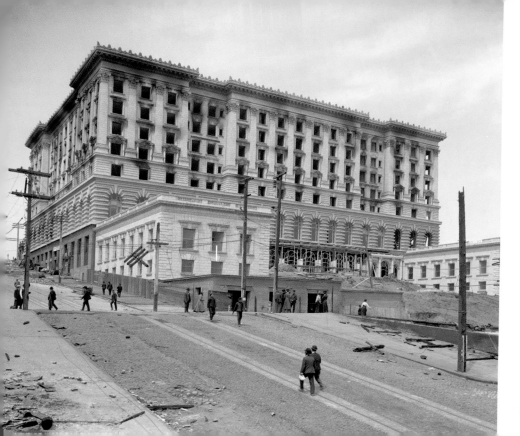

Fairmont Hotel after the Great Fire of 1906

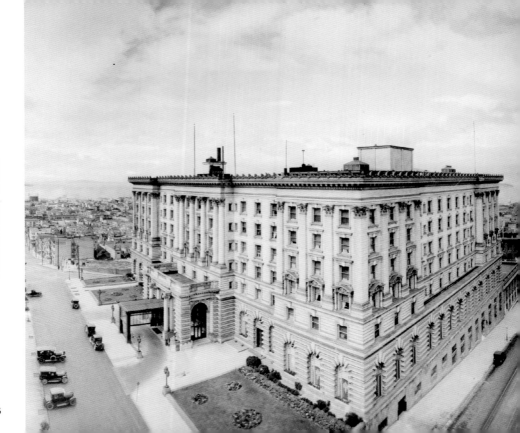

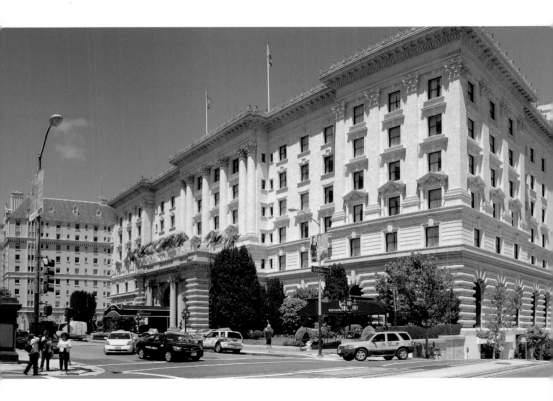

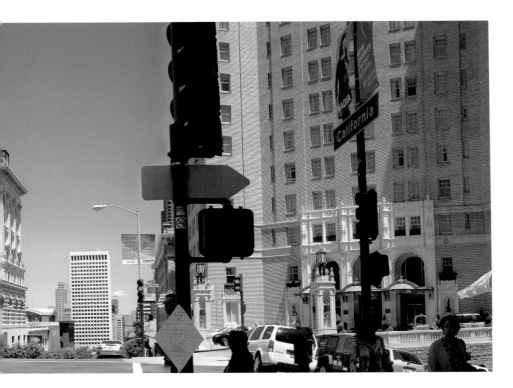

Fairmont Hotel

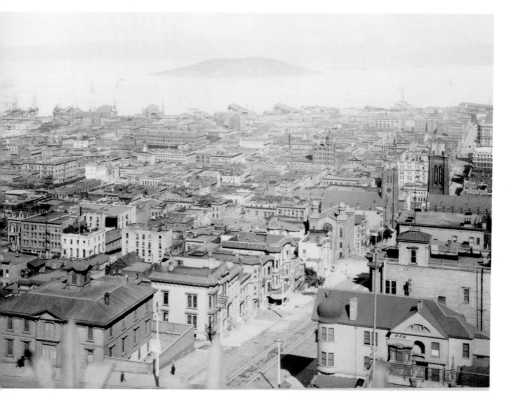

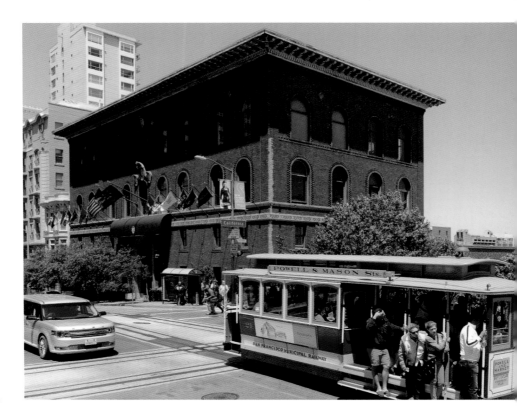

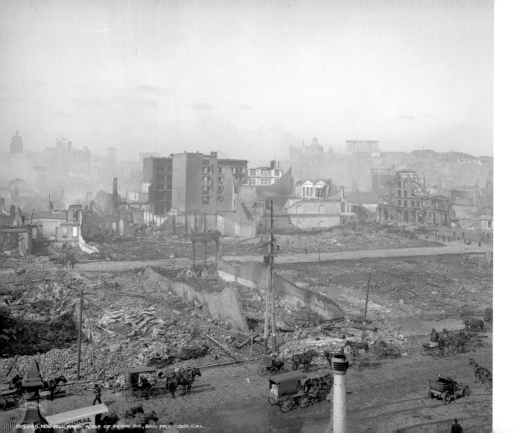

View from Ferry Building, 1906

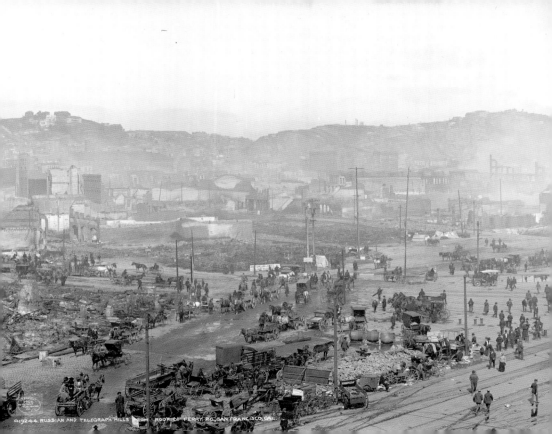
019244. RUSSIAN AND TELEGRAPH HILLS FROM ROOF OF FERRY BO. SAN FRANCISCO, CAL.

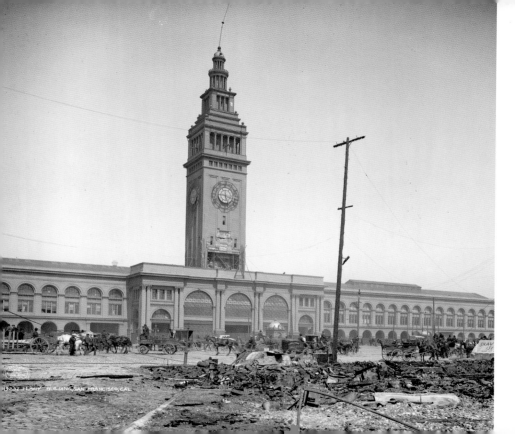

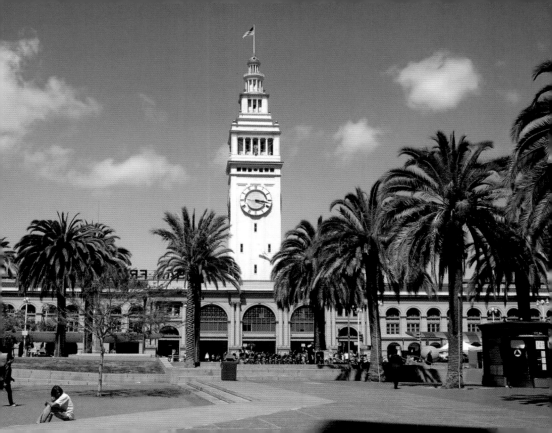

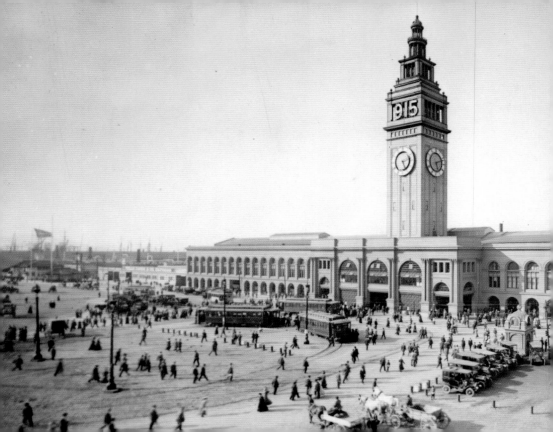

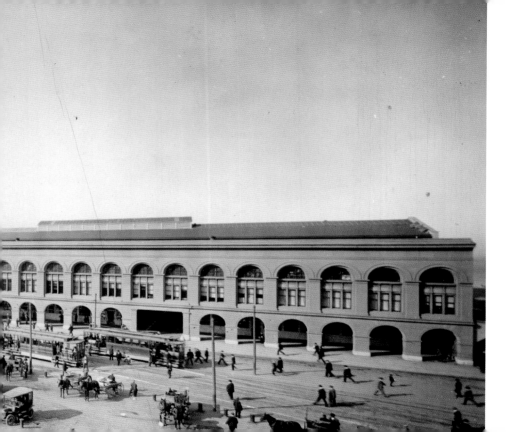

The "Evening Rush Hour" at the Ferry Building, 1915

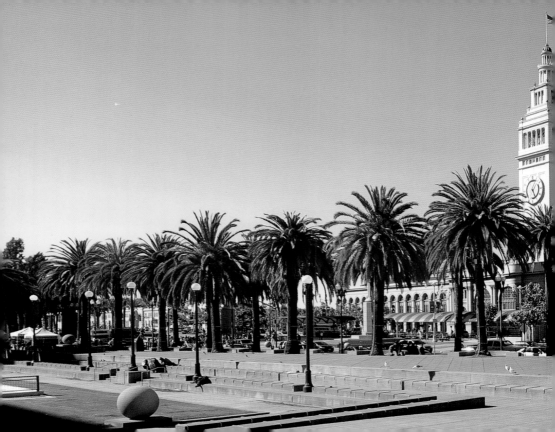

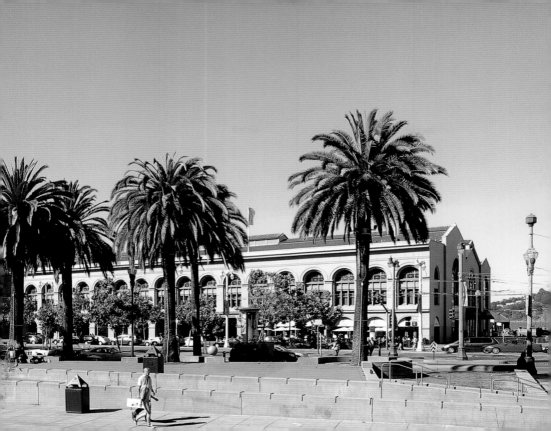

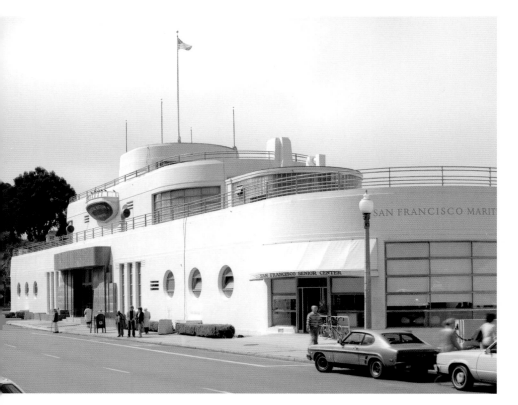

San Francisco Maritime Museum, Beach Street, c. 1980

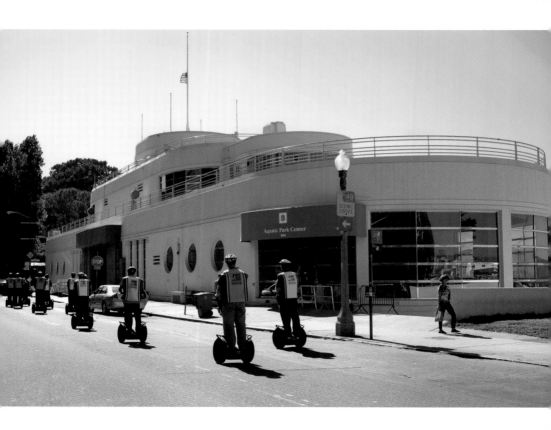

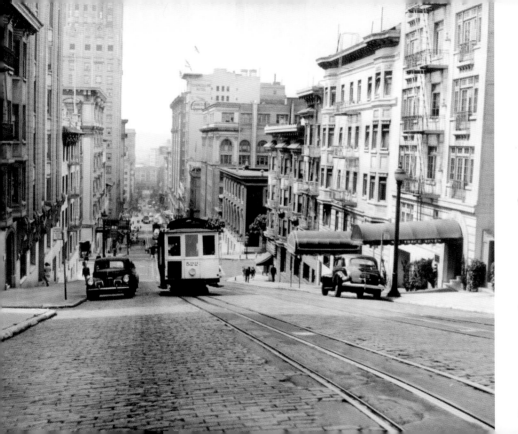

Powell Street looking south from Nob Hill, c. 1948

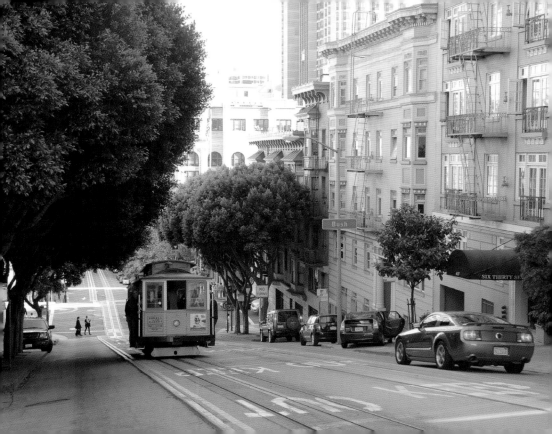

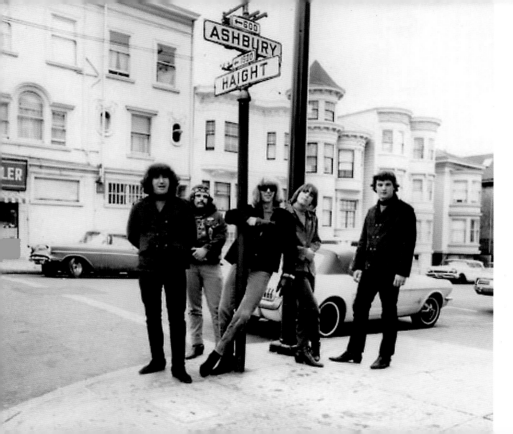

Grateful Dead at Haight Ashbury, 1967

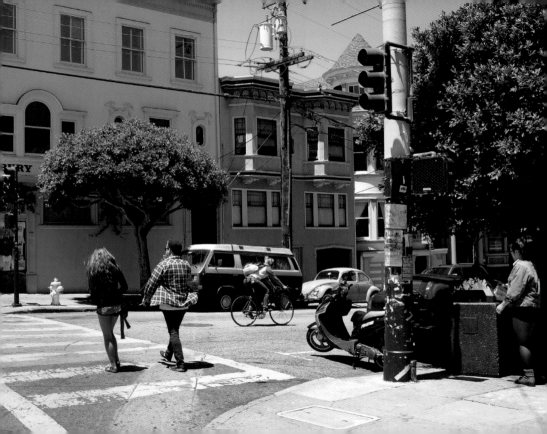

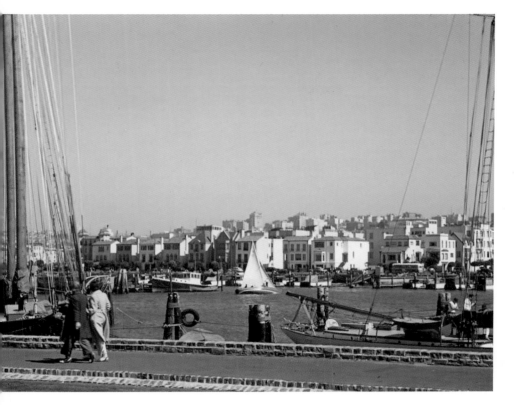

From Saint Francis Yacht Club looking toward Marina Blvd, c. 1955

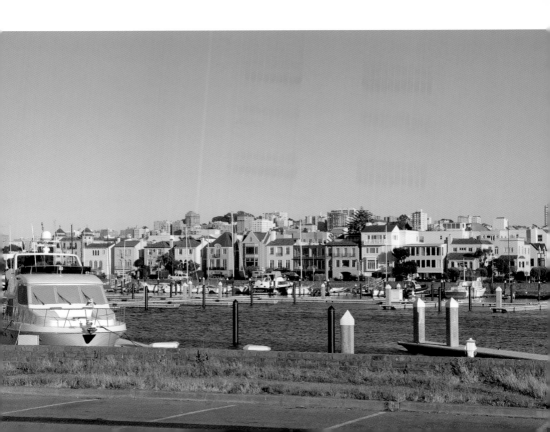

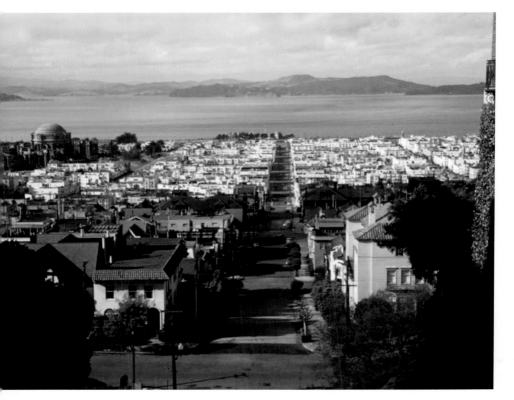

Looking north from Broadway down Baker Street, c. 1951

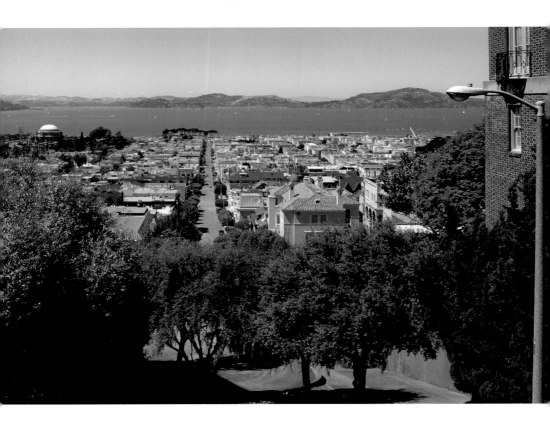

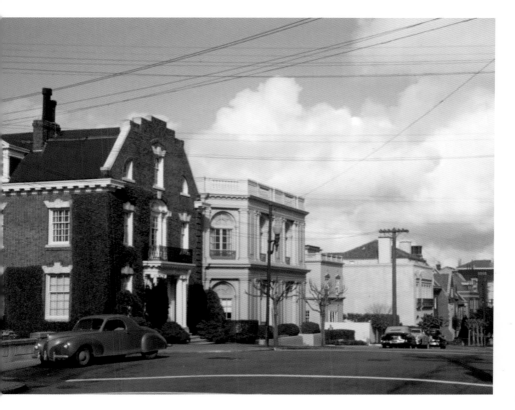

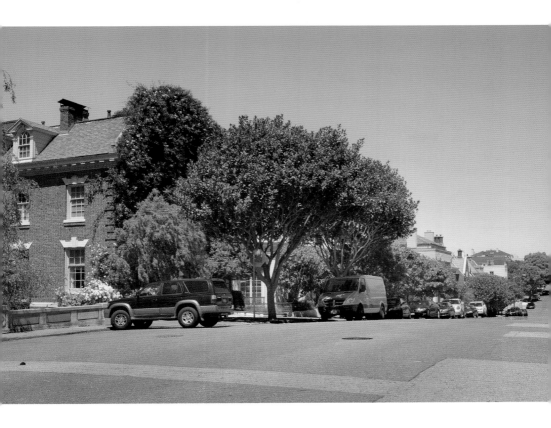

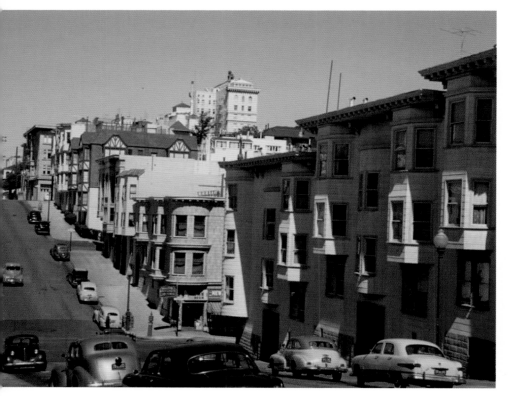

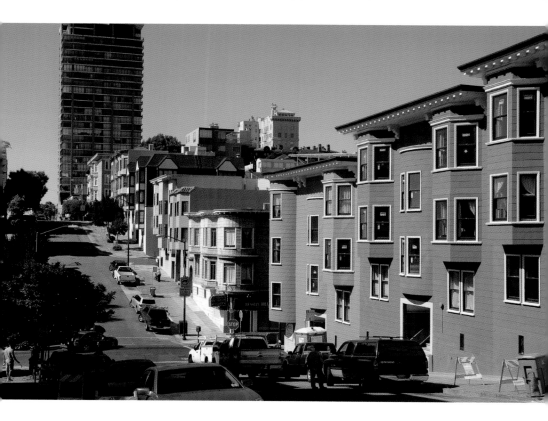

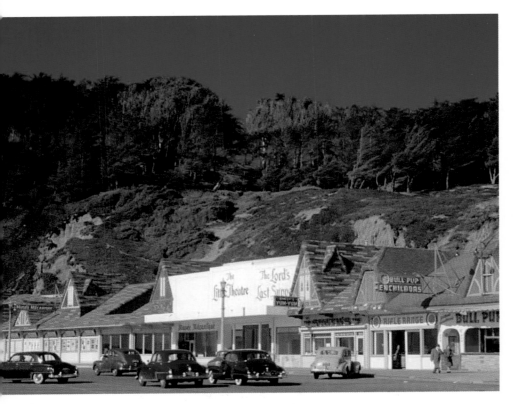

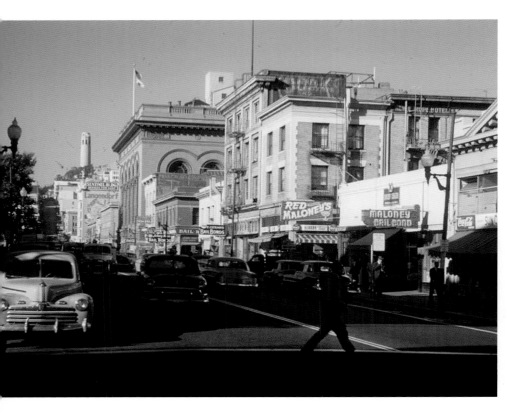

Looking North on Kearney Street, c. 1955

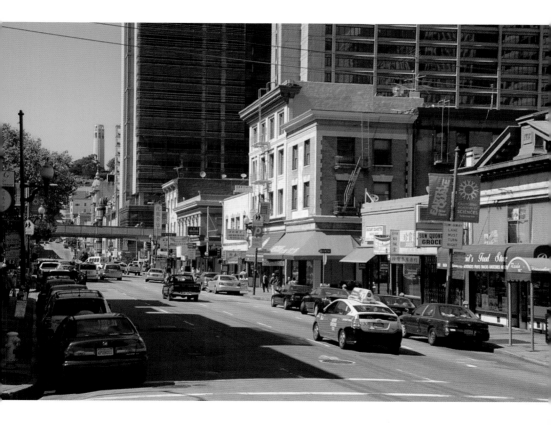

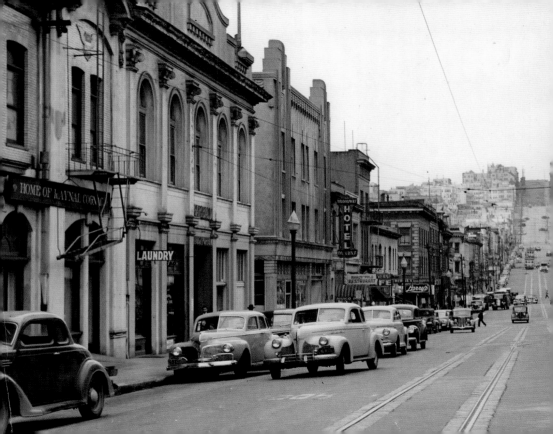

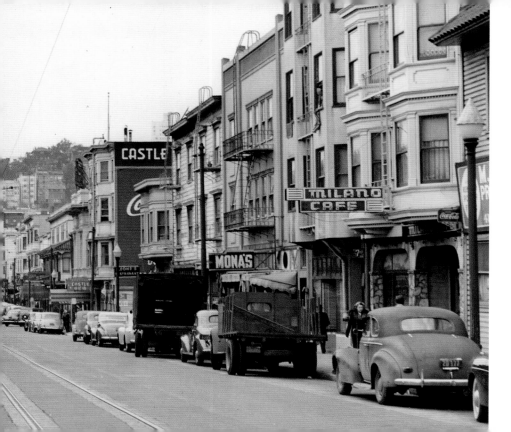

Broadway and Montgomery looking toward Russian Hill, April, 1944

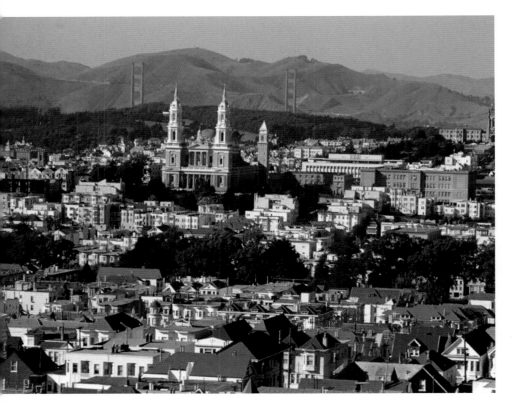

View from Mount Olympus, c. 1951

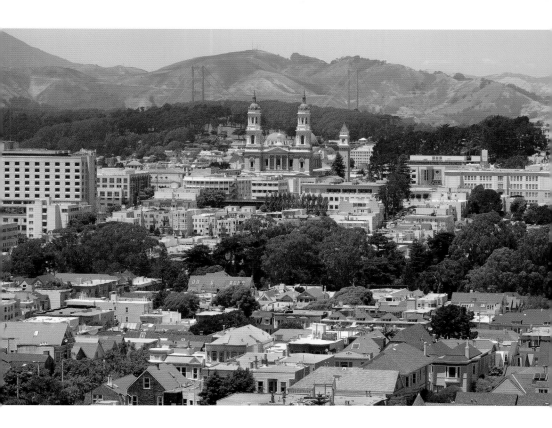

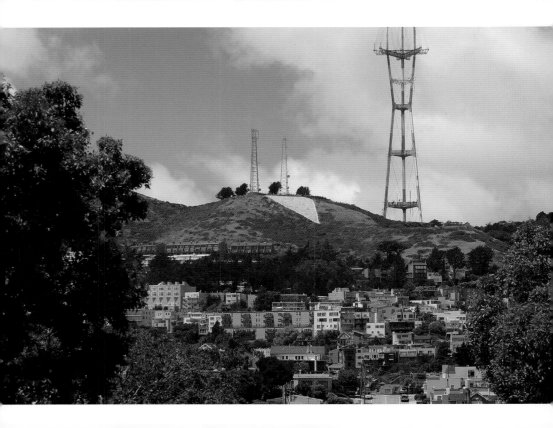

Gay Pride, the Castro District, 2012

59

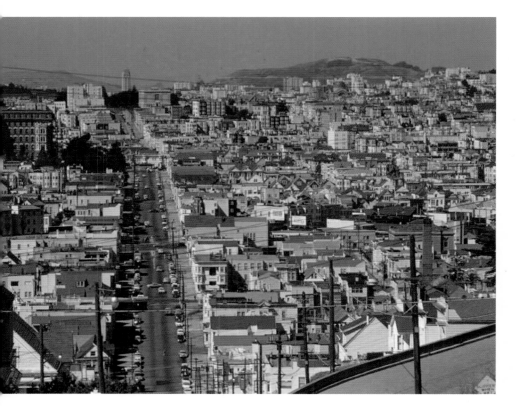

Looking North on Noe Street from near Liberty Street, c. 1955

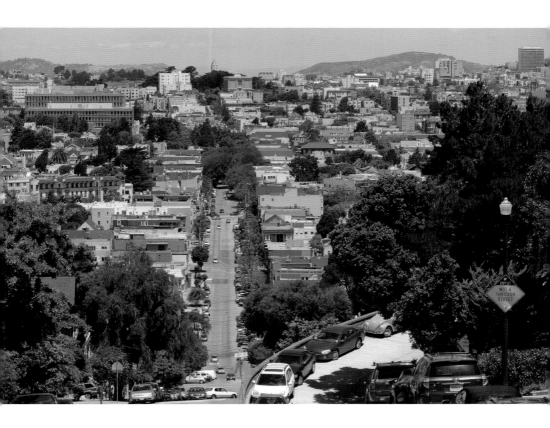

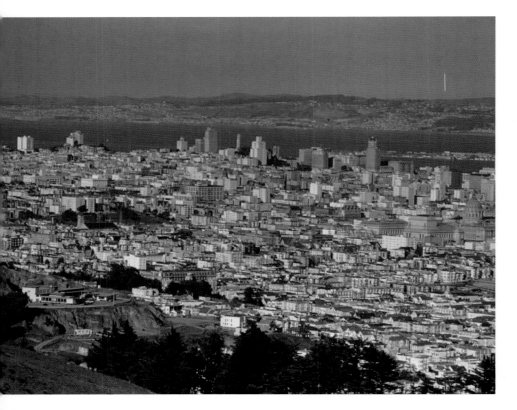

View from Twin Peaks, c. 1955

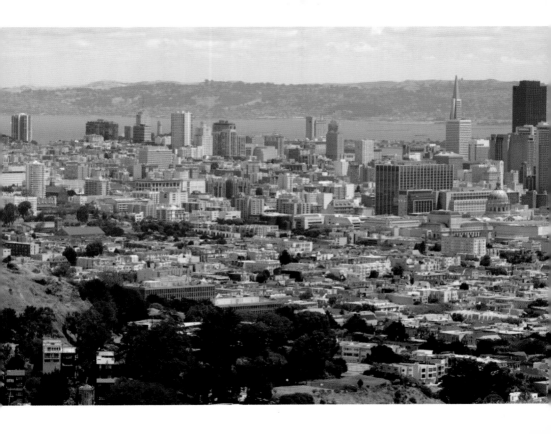

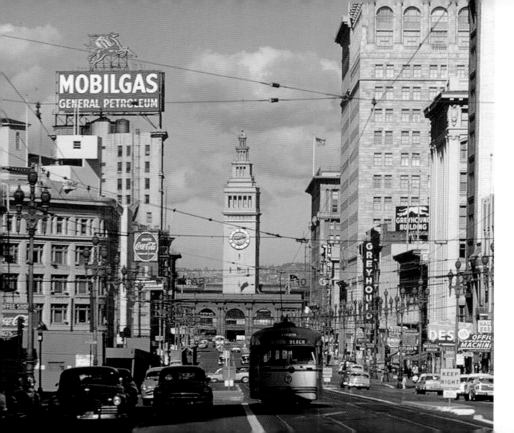

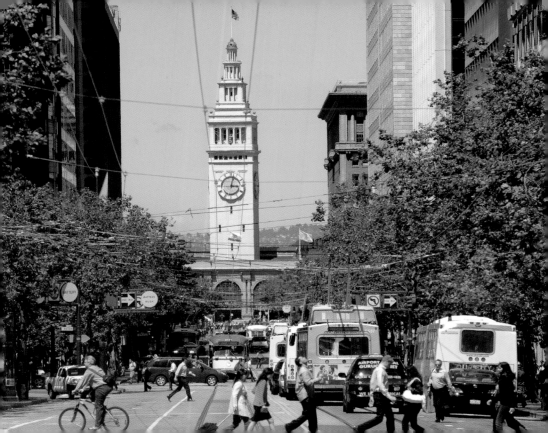

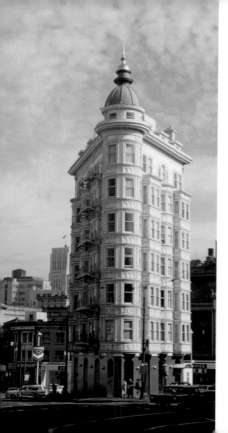

Sentinel Building, c. 1962

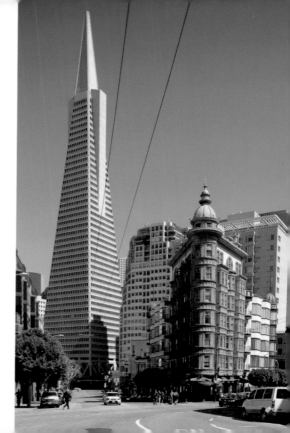

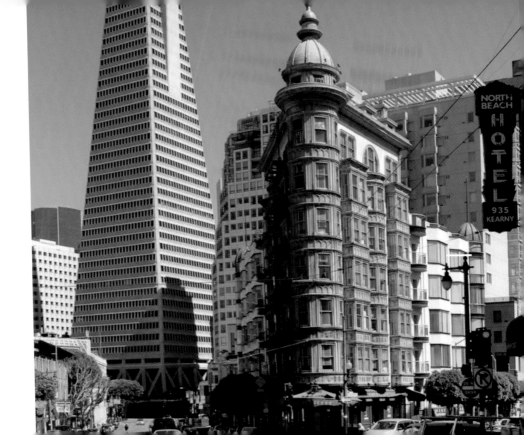

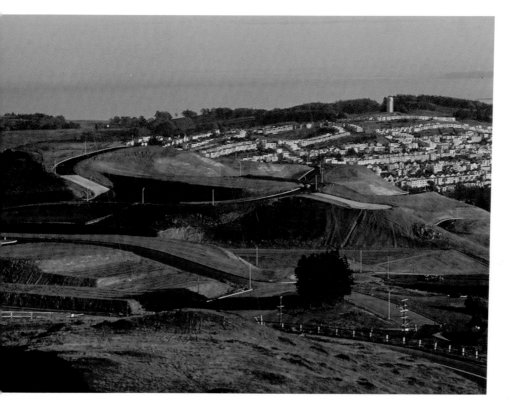

Diamond Heights, c. 1951

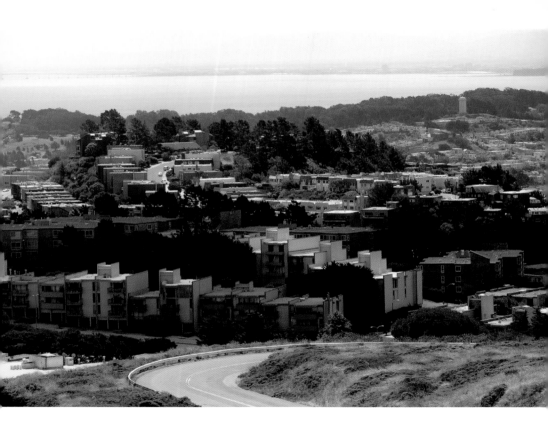

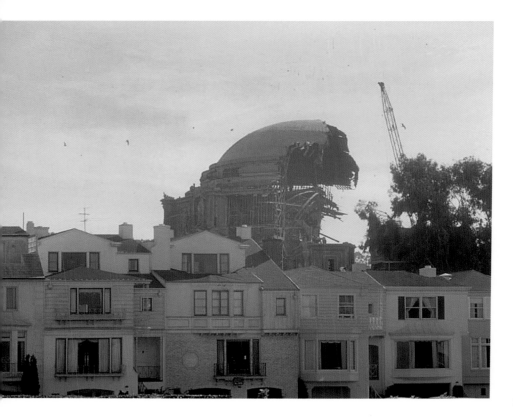

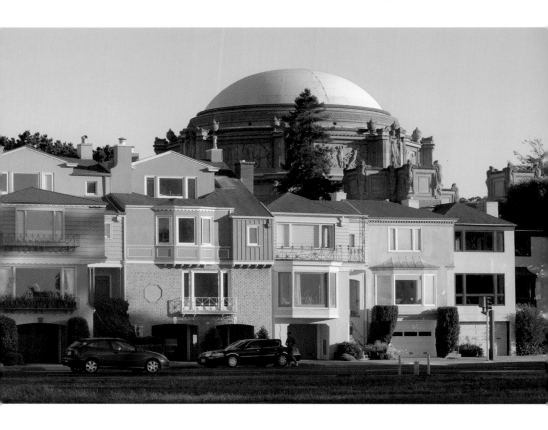

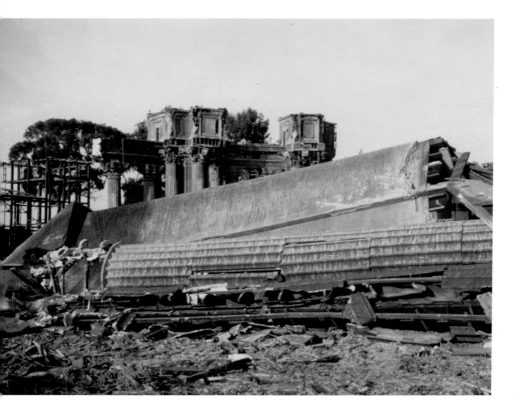

Palace of Fine Arts renovation, 1964

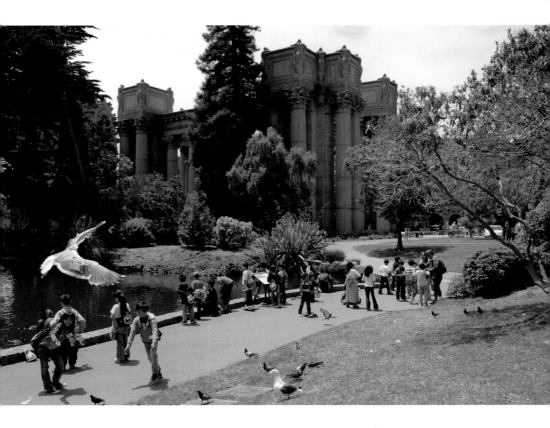

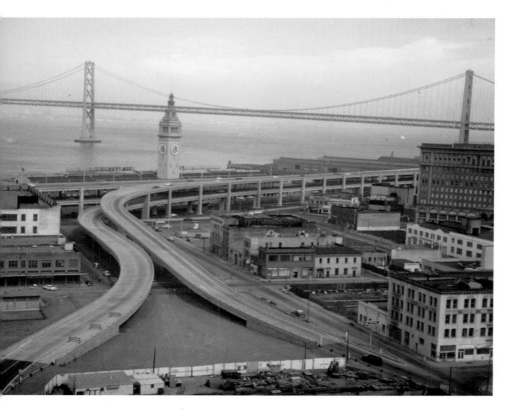

The Ferry Building and Bay Bridge, c. 1960

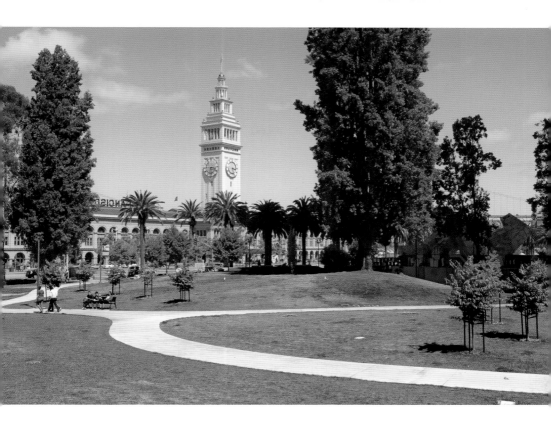

Hobart Building on Market Street, c. 1966

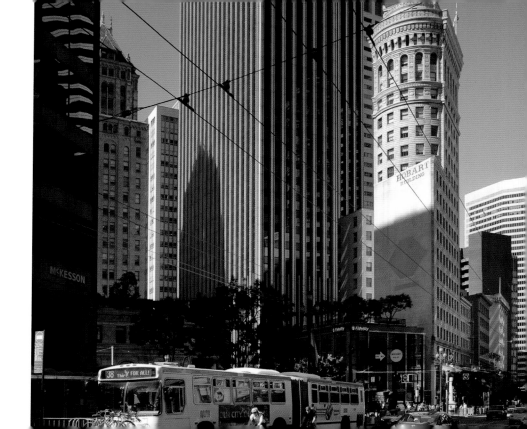

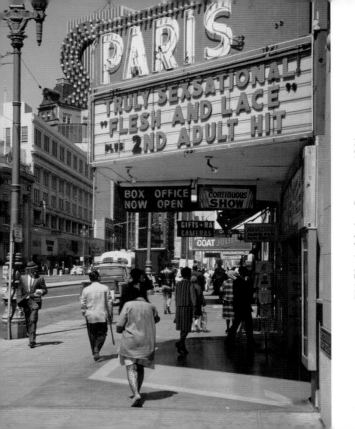

700 Block, Market Street, c. 1966

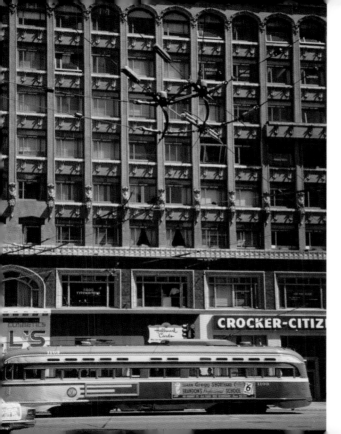

800 Block, Market Street, c. 1966

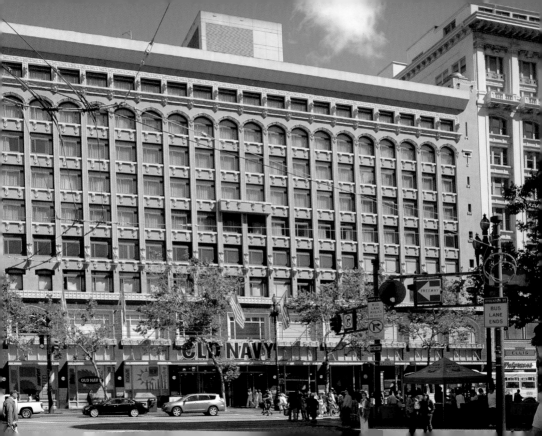

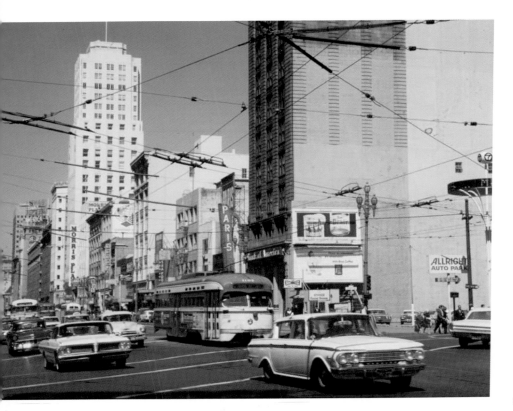

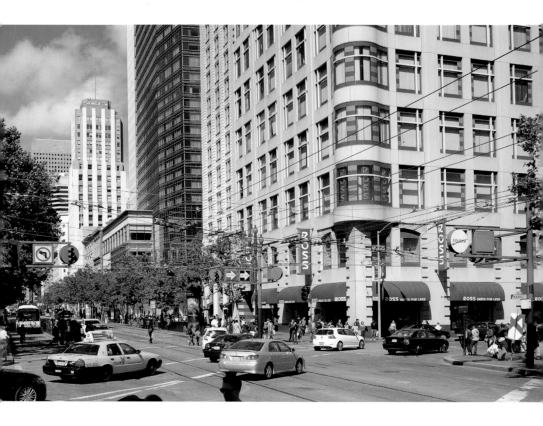

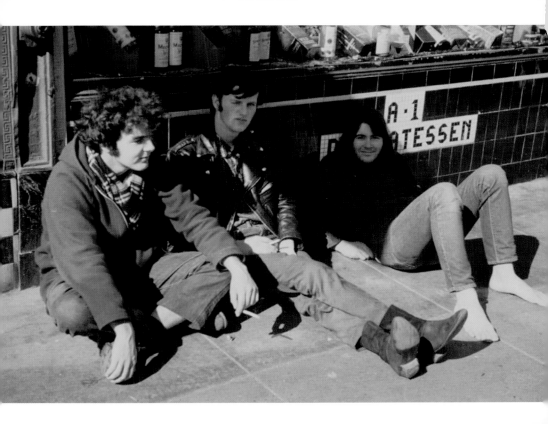

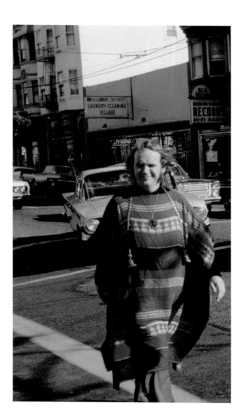

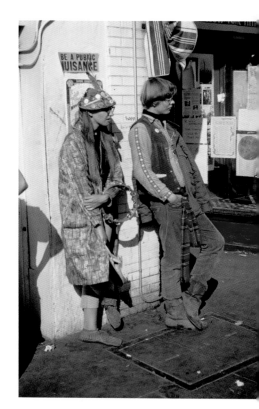

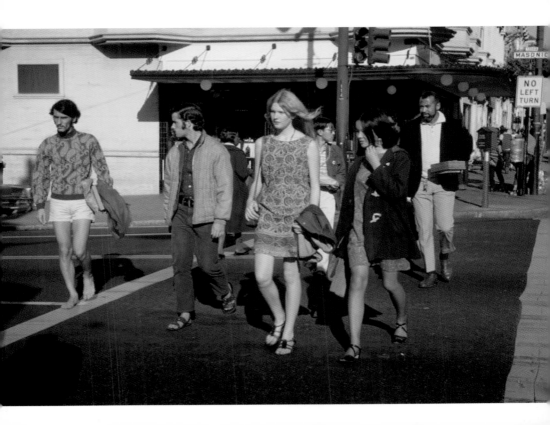

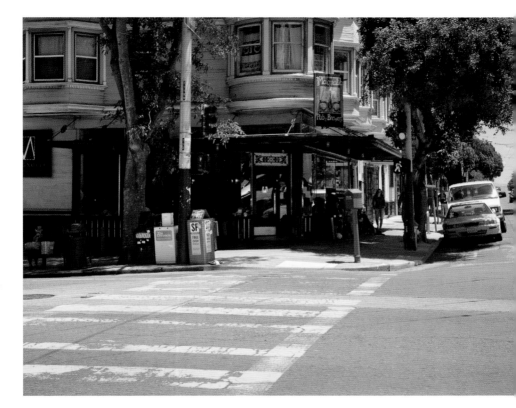

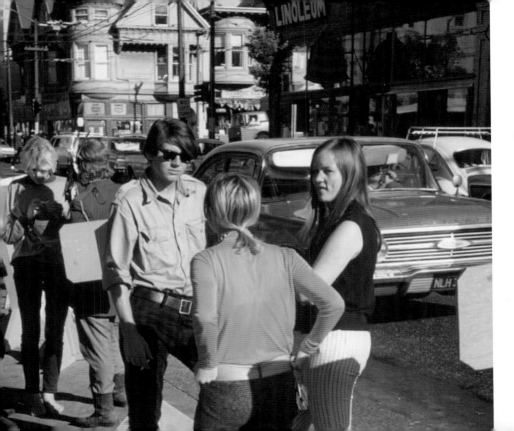

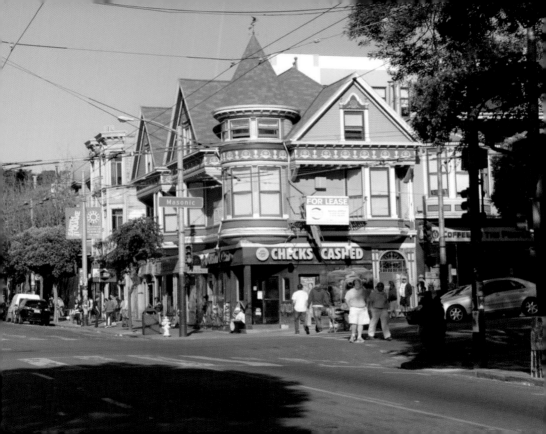

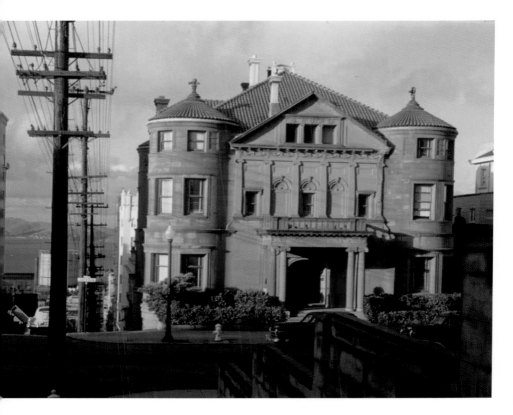

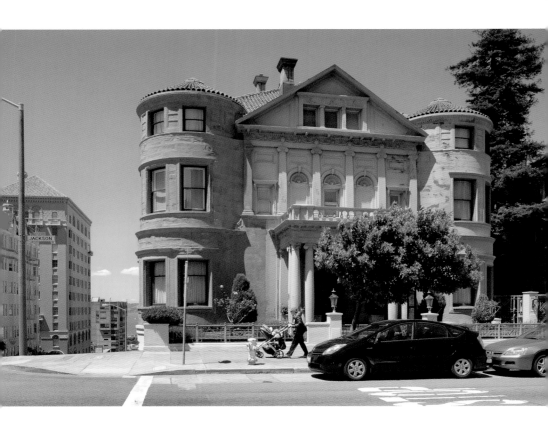

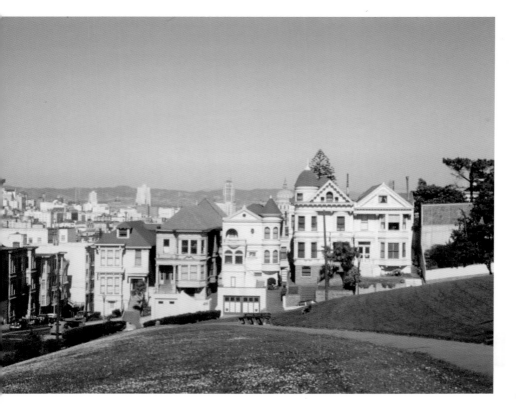

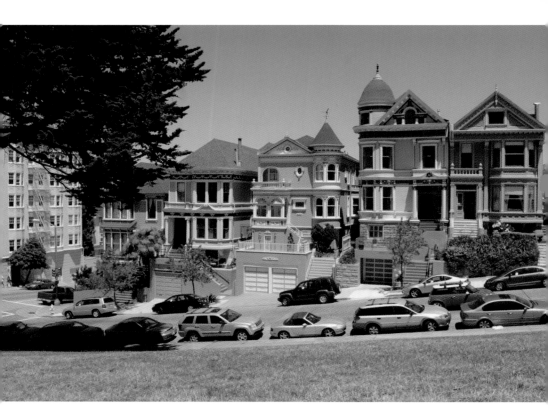

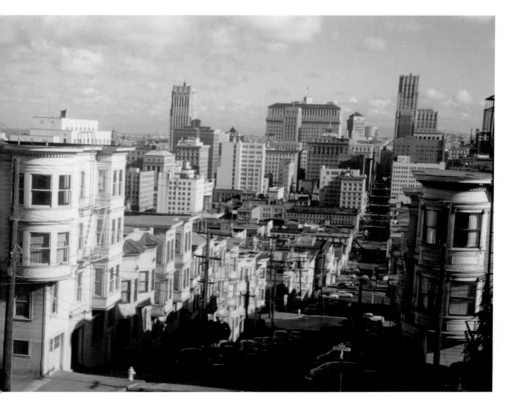

Looking south on Montgomery from Green Street, c. 1951

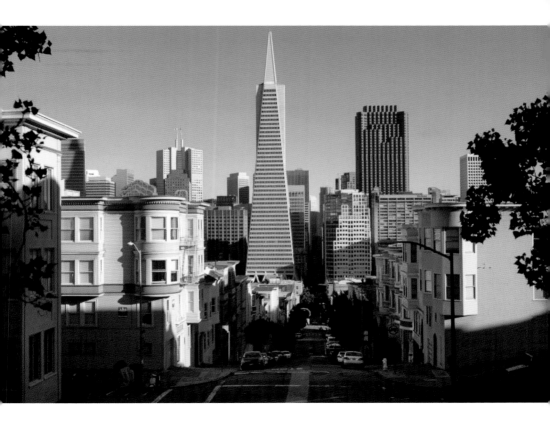

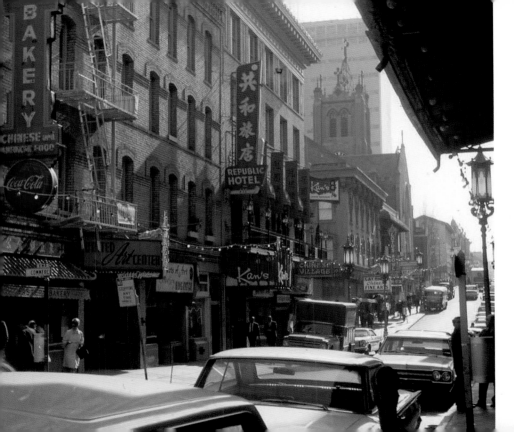

Grant Avenue, Chinatown, c. 1965

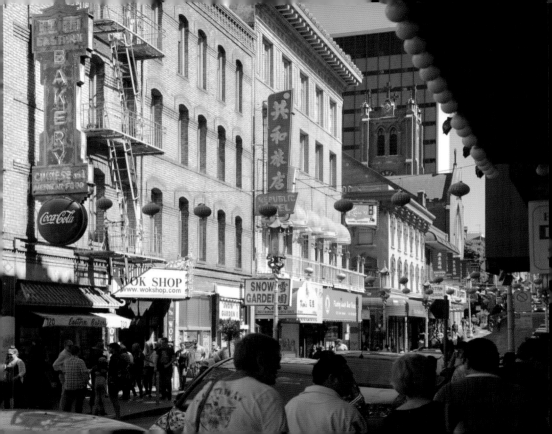

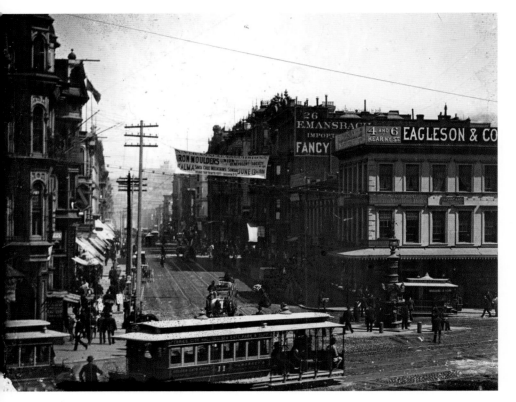

Looking north on Kearney Street at Market Street, c. 1892

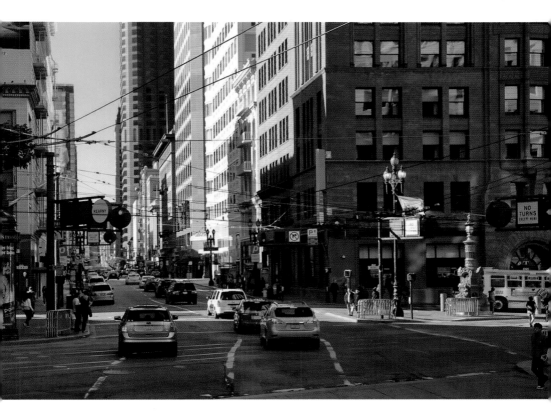

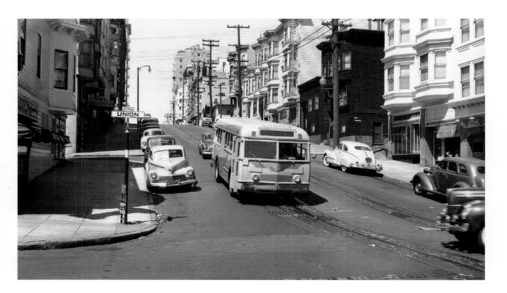

Hyde Street looking north at Union, c. 1951

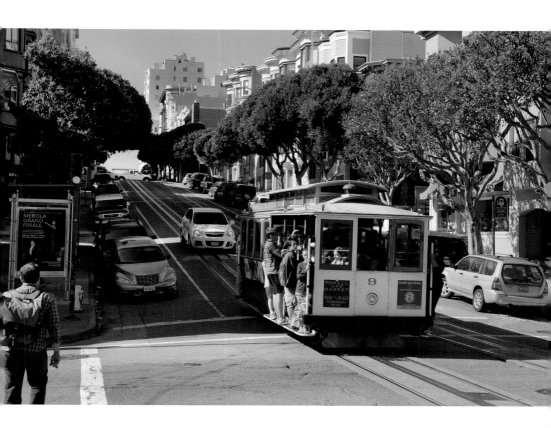

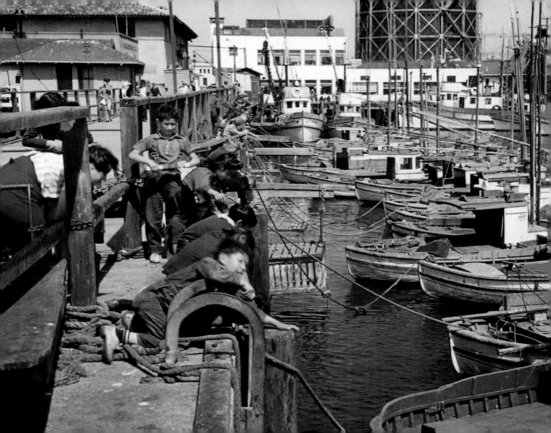

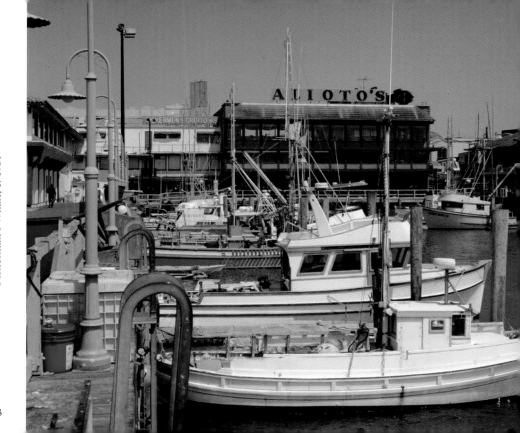

Fisherman's Wharf, c. 1957

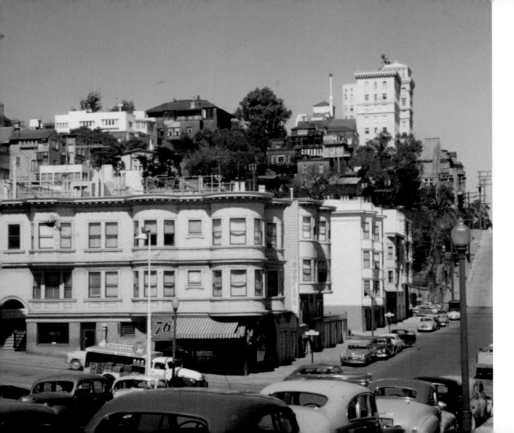

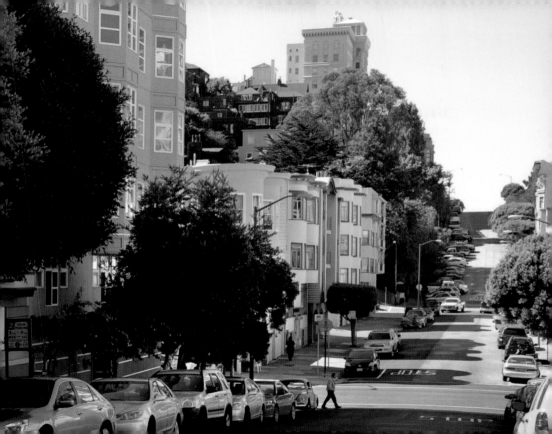

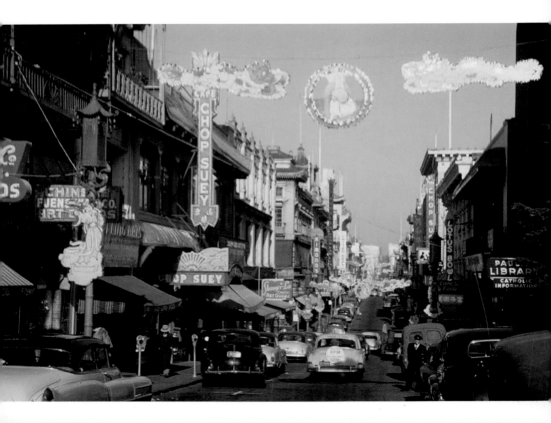

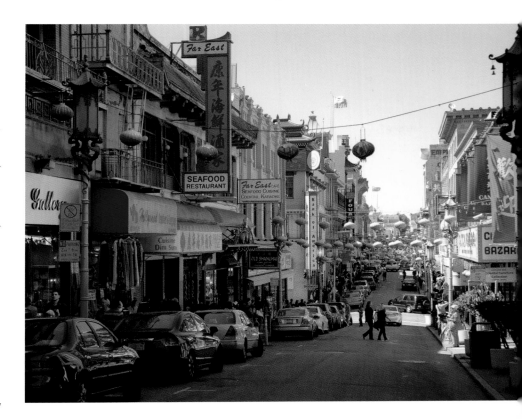

Grant Avenue, Chinatown, c. 1952

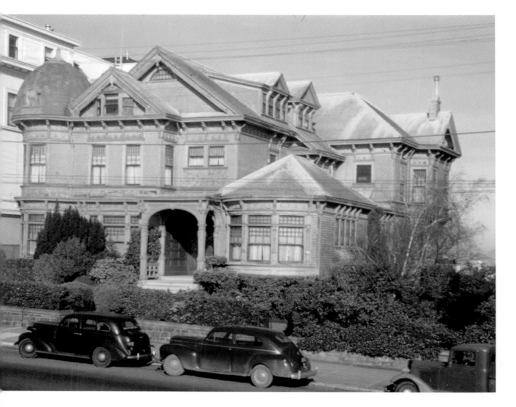

2500 block of Jackson Street, Pacific Heights, c. 1952

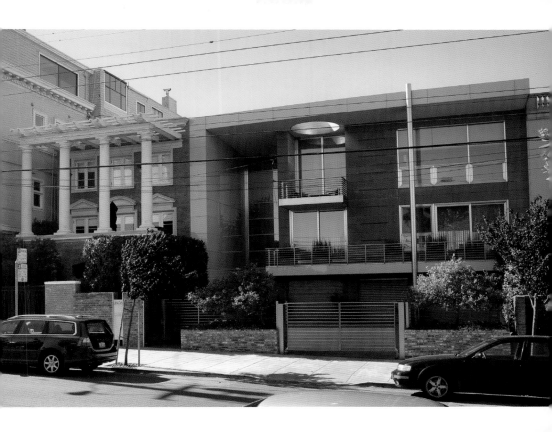

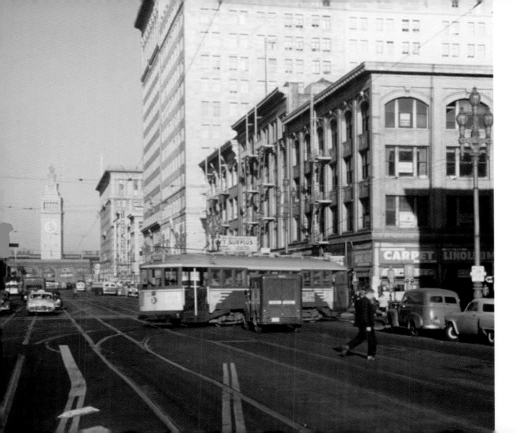

Market Street, c. 1955

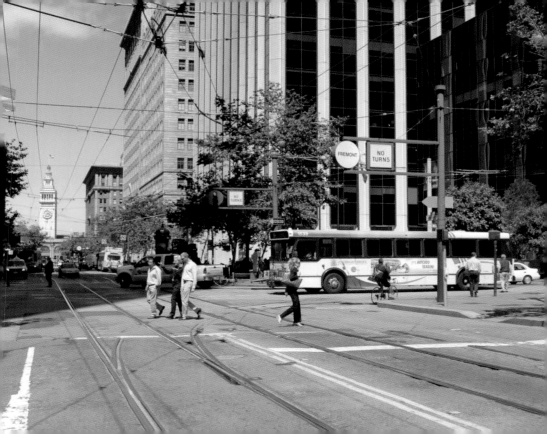

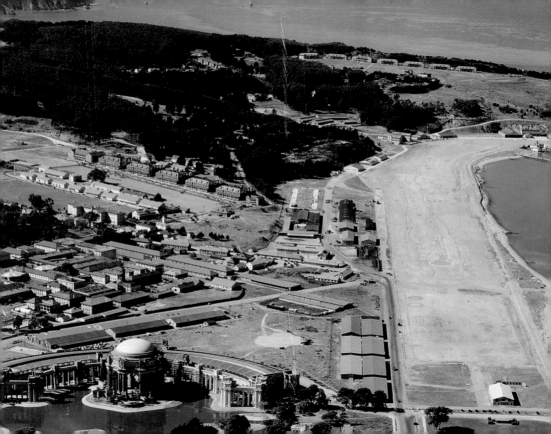

The Presidio of San Francisco, Crissy Field and Fort Point, 1930

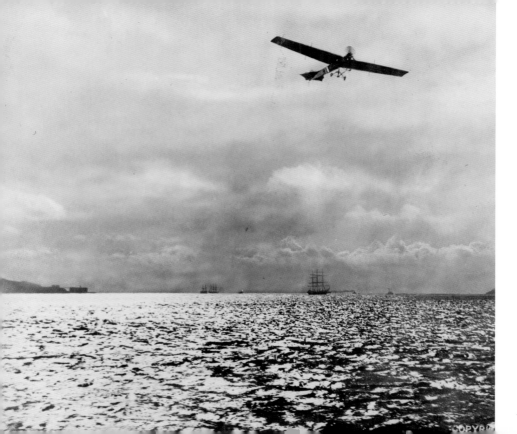

Latham flying over the Golden Gate, c. 1911

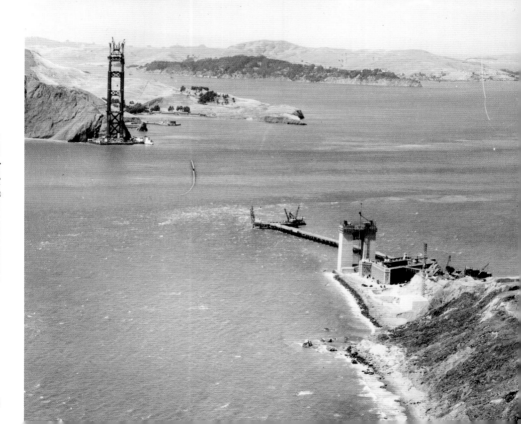

Golden Gate Bridge, July 1934

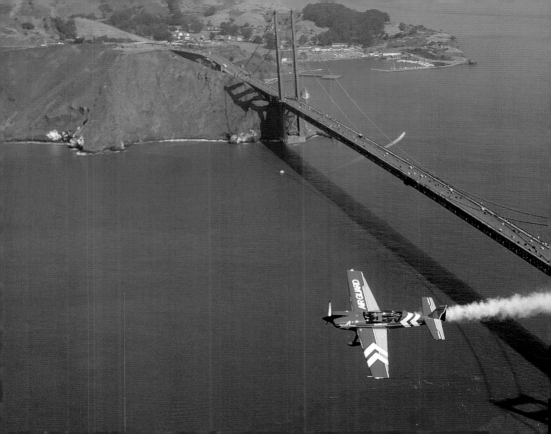

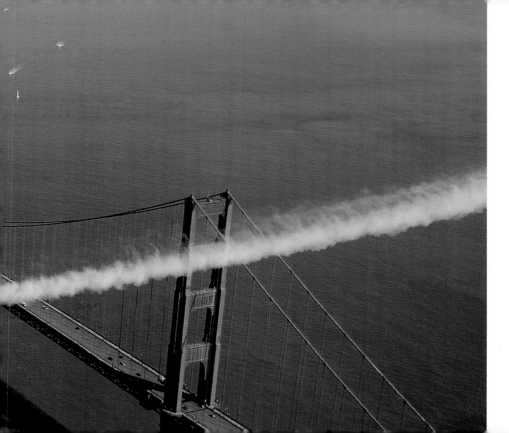

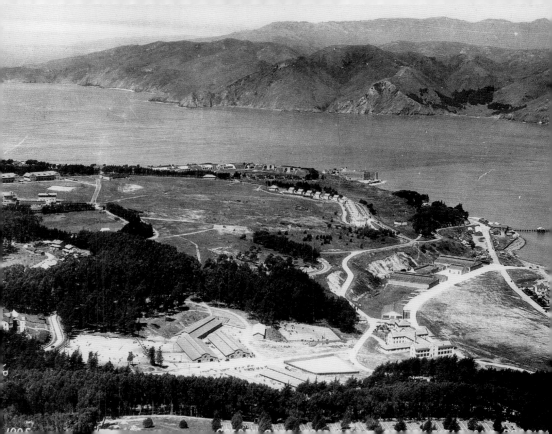

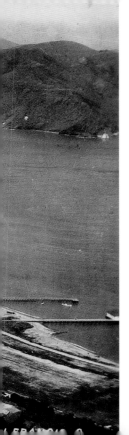

The Golden Gate and Fort Point, c. 1925

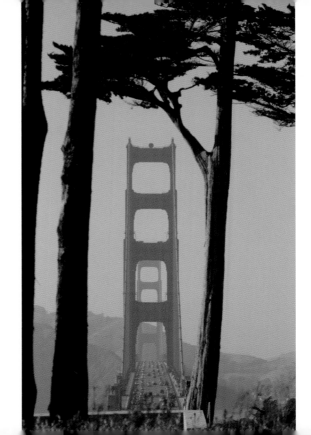

Golden Gate Bridge from the south

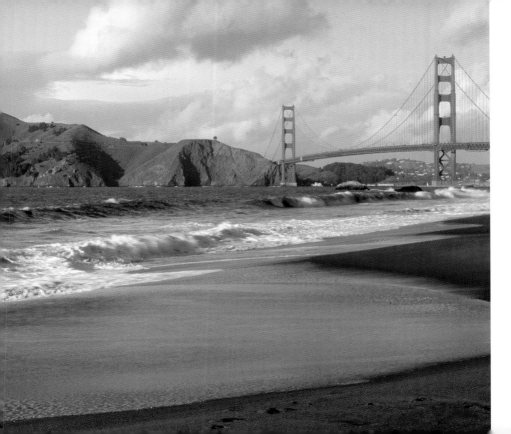

Golden Gate Bridge, c. 2005

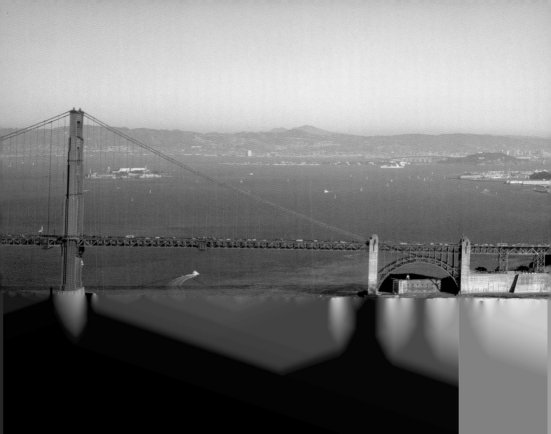

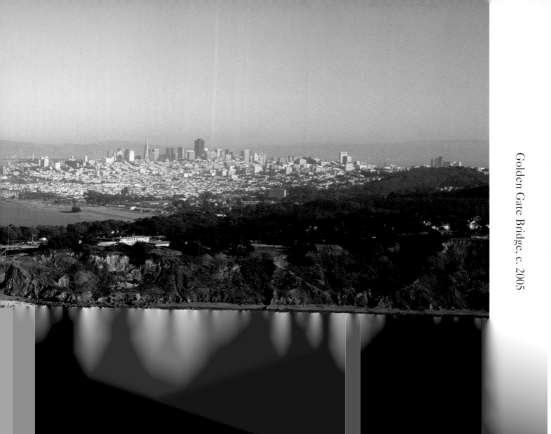

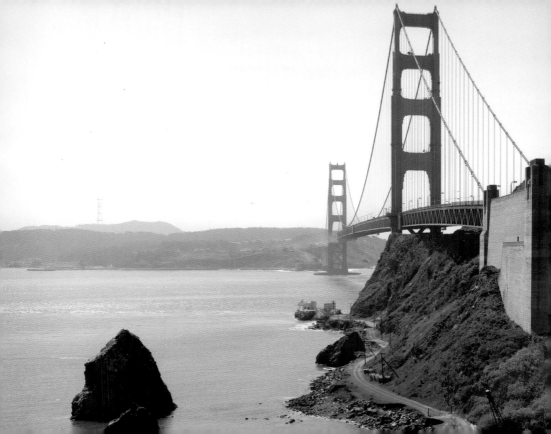

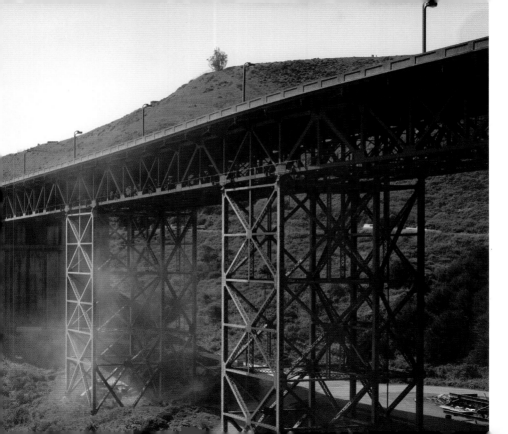

Golden Gate Bridge from the north, c. 1975

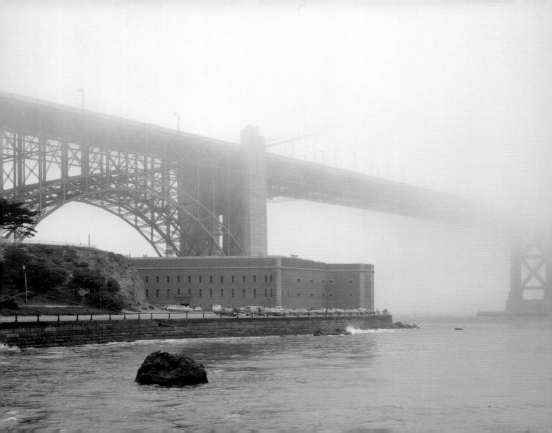

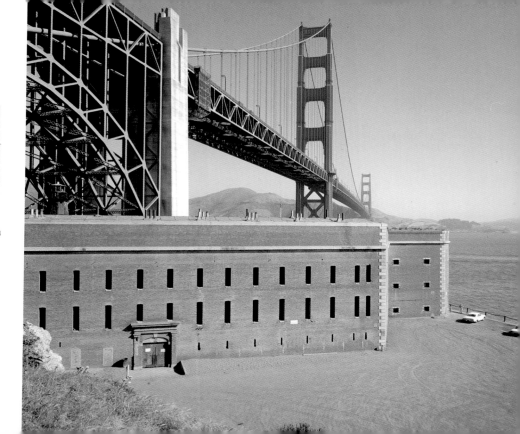

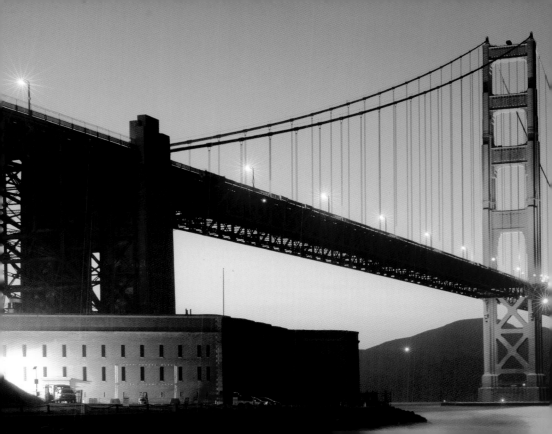

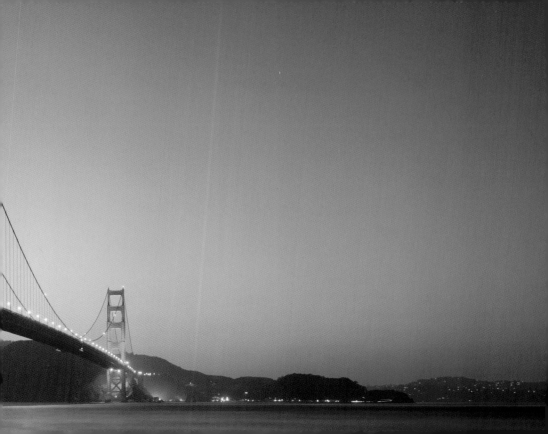

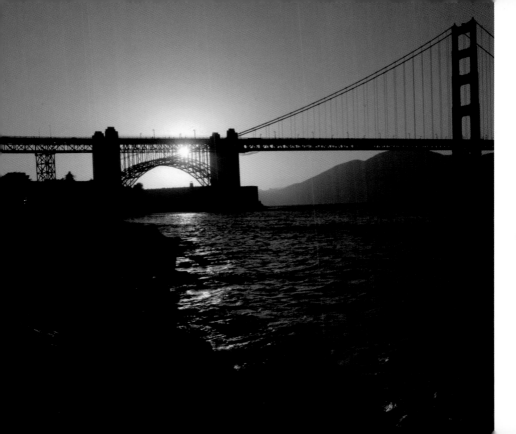

Golden Gate Bridge at sunset

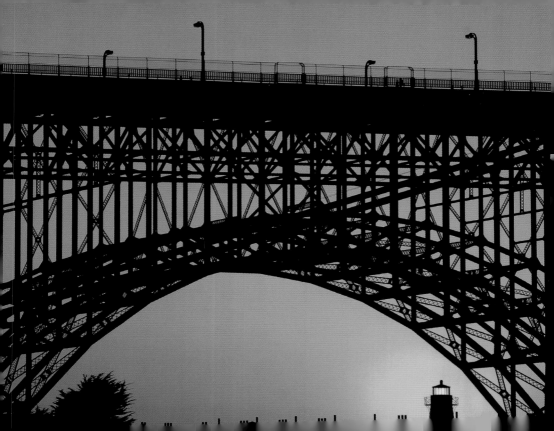

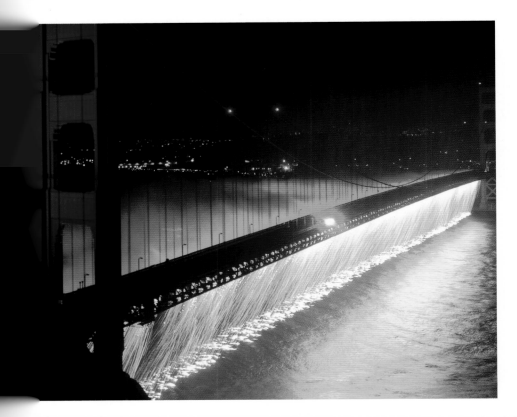

Golden Gate Bridge, 75th Anniversary fireworks, 2012

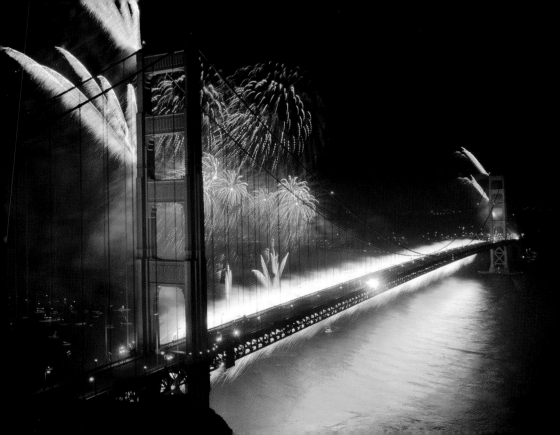

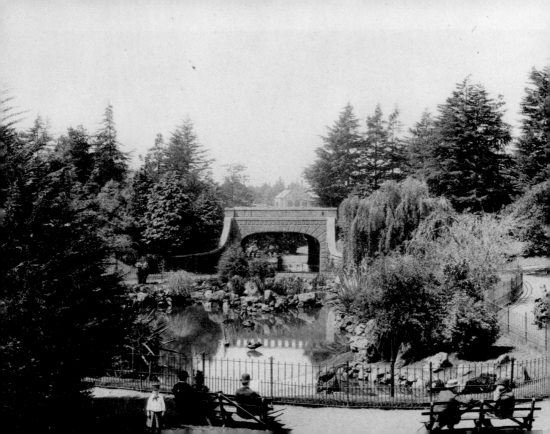

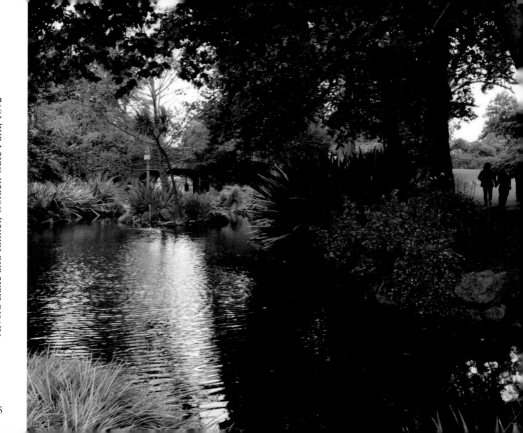

Alvord Lake and tunnel, Golden Gate Park, 1892

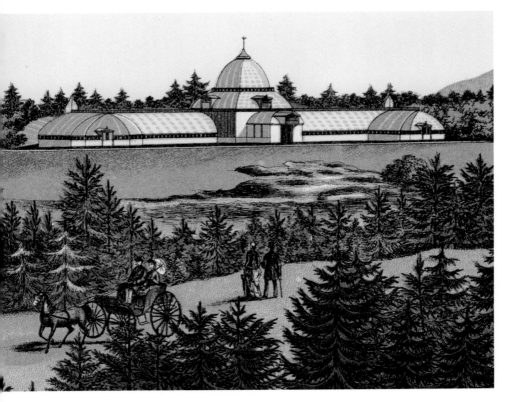

Golden Gate Park Conservatory illustration, 1886

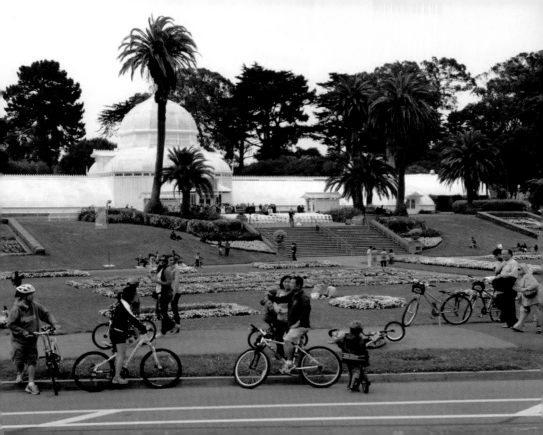

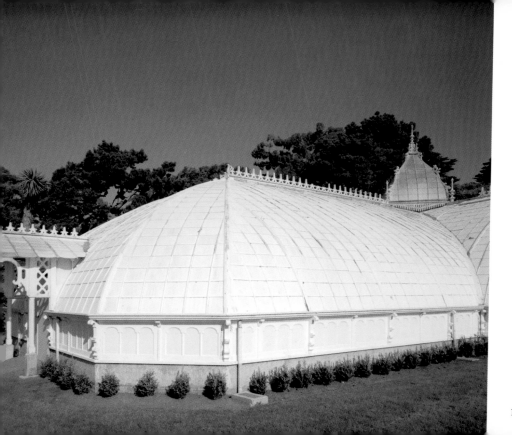

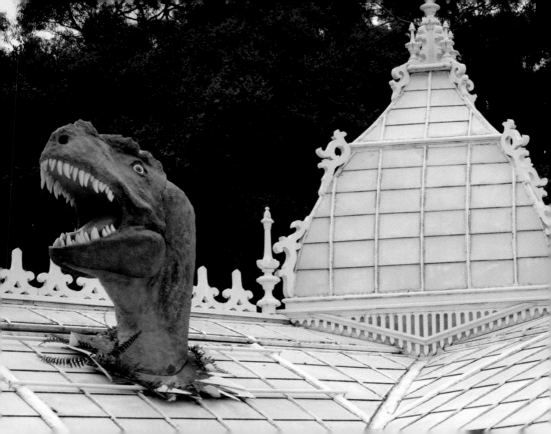

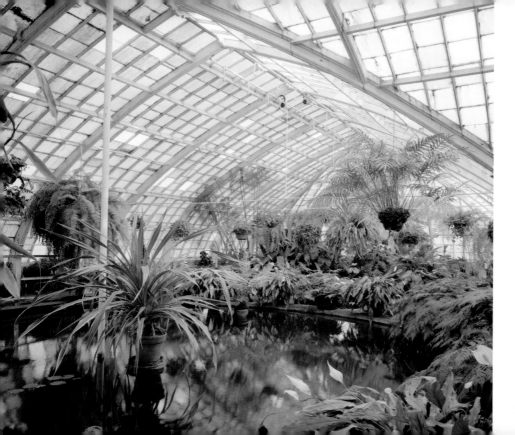

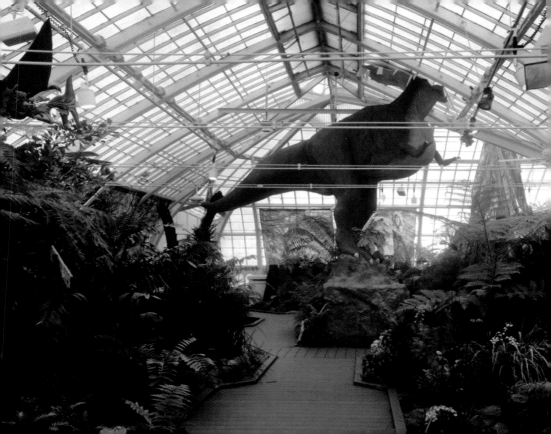

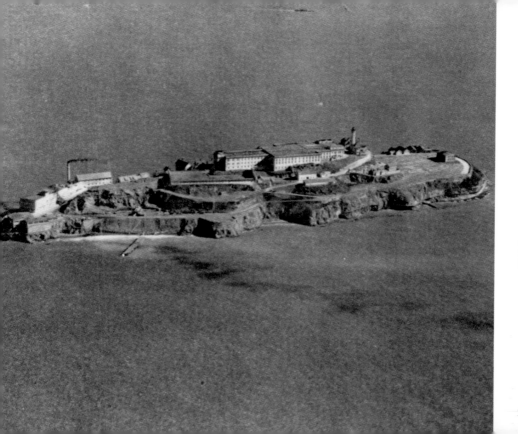

Alcatraz Island, 1928

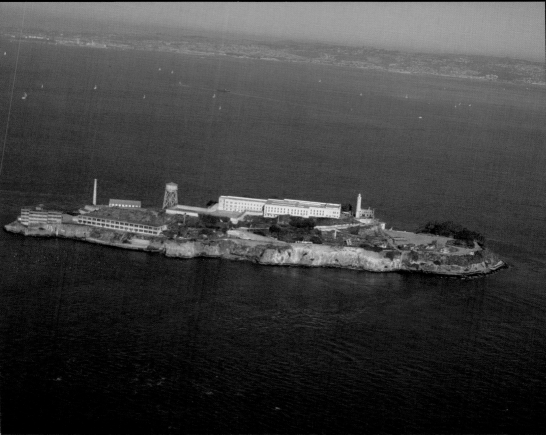

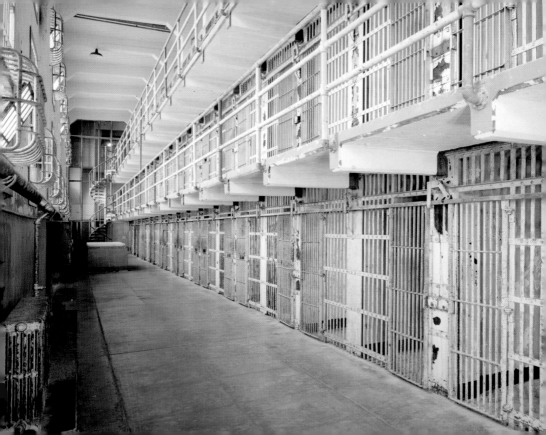

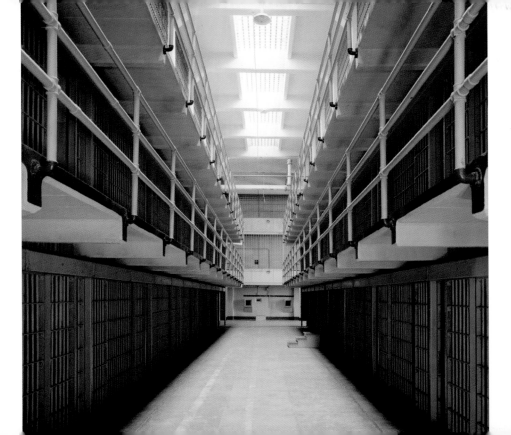

Alcatraz Island, c. 1978

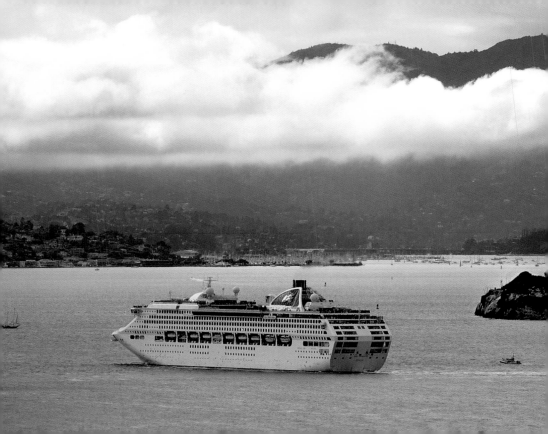

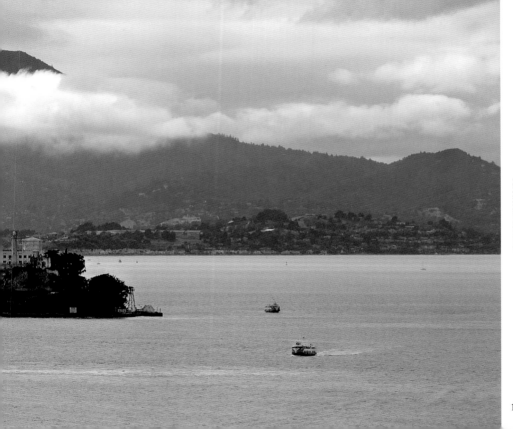

Alcatraz Island

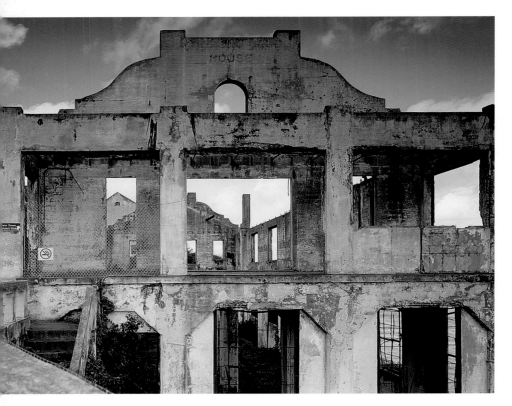

The burned out Officers' Club on Alcatraz Island, c. 2005

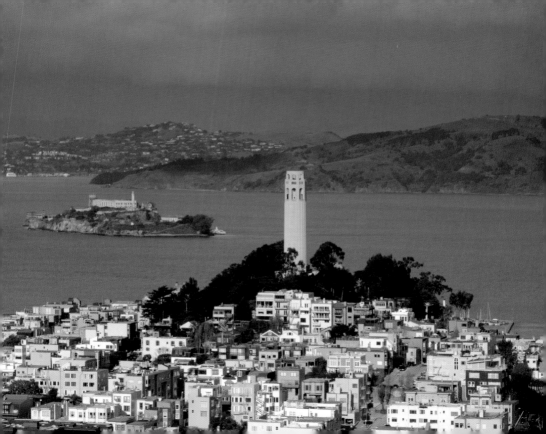

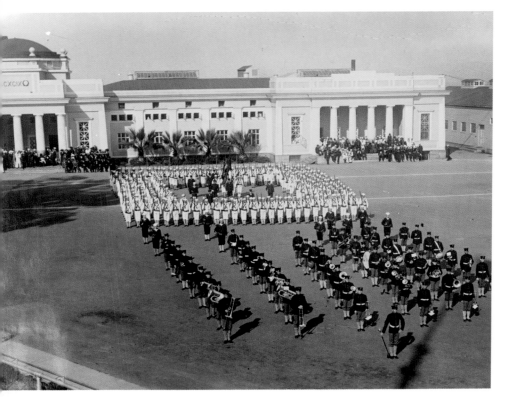

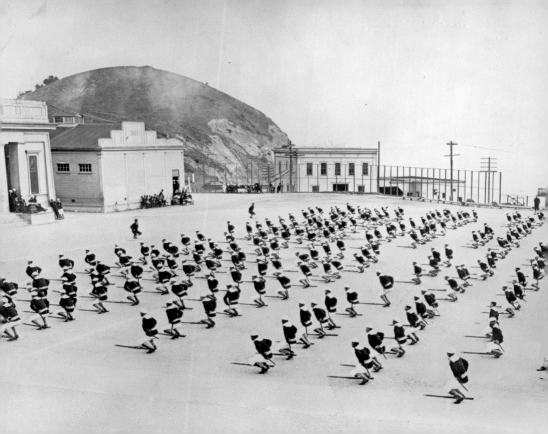

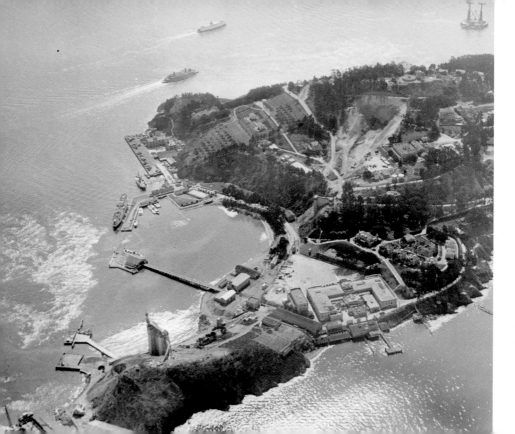

Yerba Buena Island, the Naval Station is at bottom right, 1936

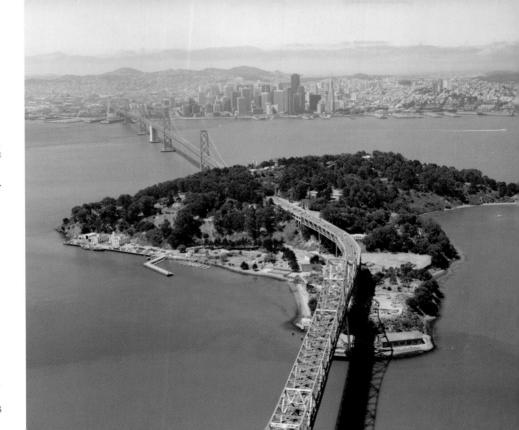

Yerba Buena Island and Bay Bridge, 1998

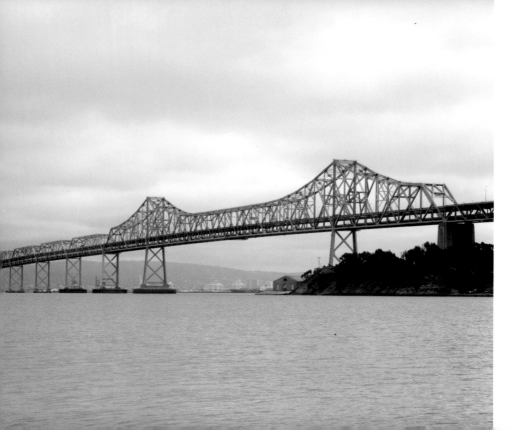

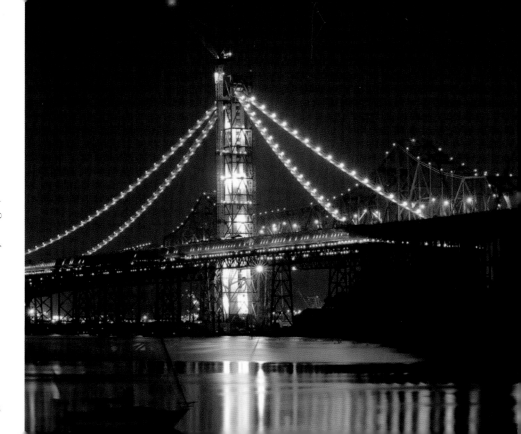

Bay Bridges, 2012

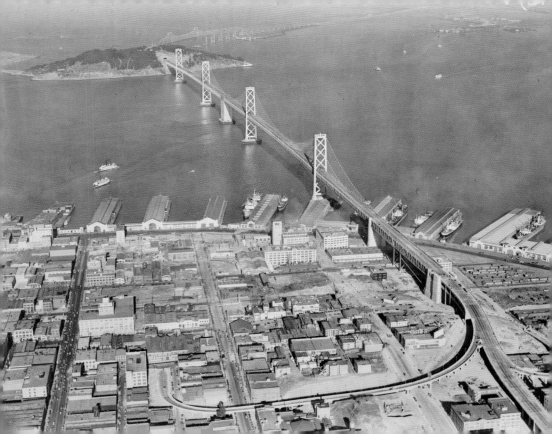

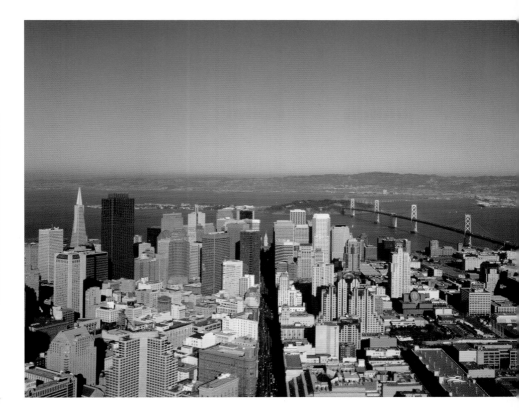

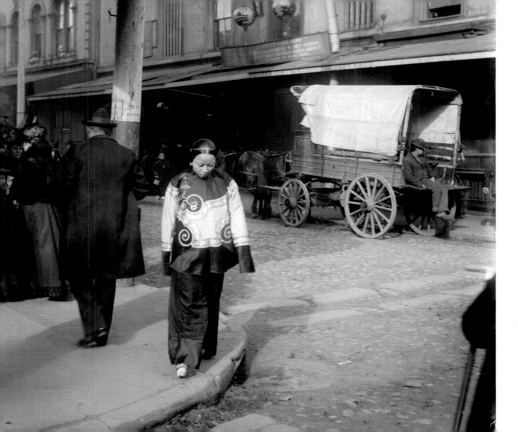

A "slave girl in holiday attire," Chinatown, c. 1900

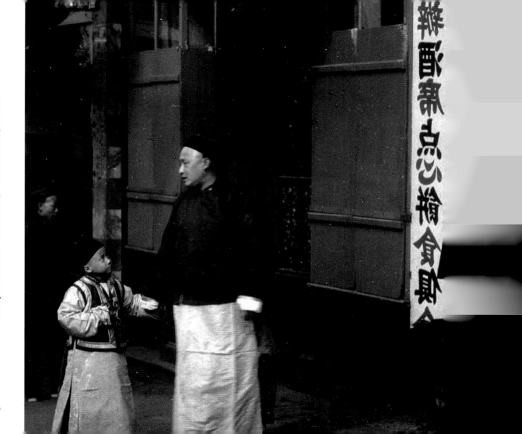

"A family from the Consulate," Chinatown, c. 1900

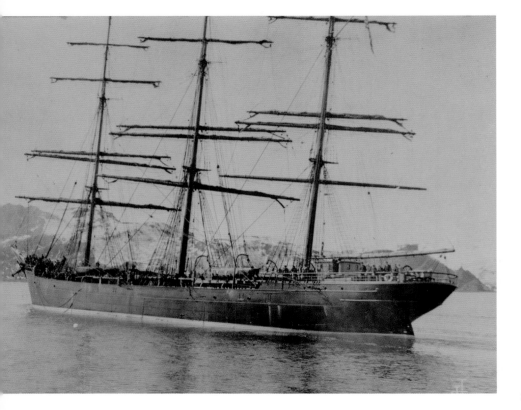

Balclutha, renamed Star of Alaska, 1913

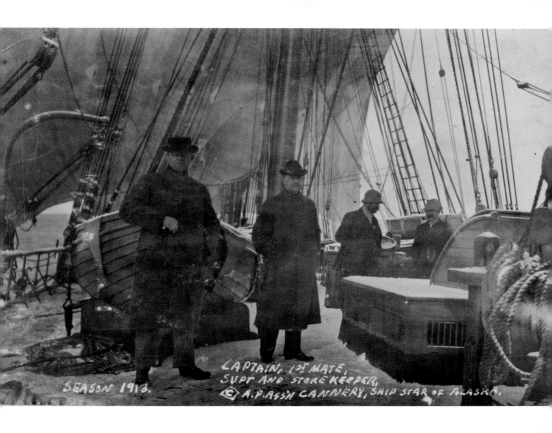

SEASON 1913.

CAPTAIN, 1ST MATE,
SUPT AND STORE KEEPER,
© A.P. Ass'n CANNERY, SHIP STAR OF ALASKA.

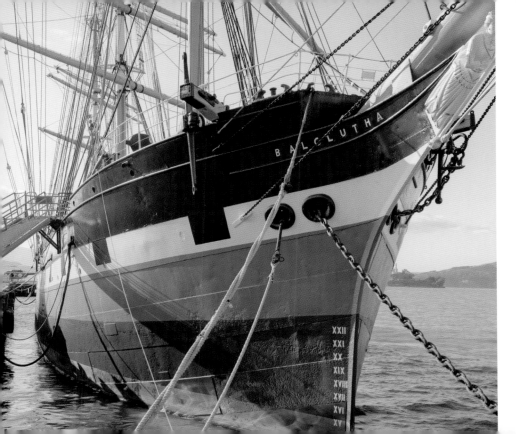

Balclutha, restored and berthed at Hyde Street Pier, c. 1978

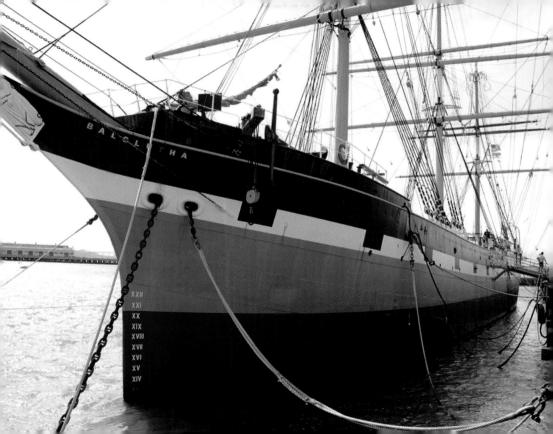

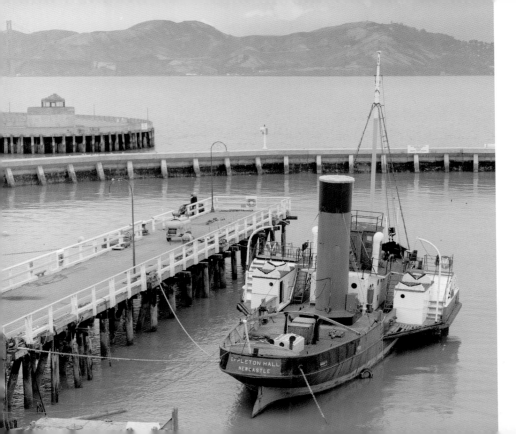

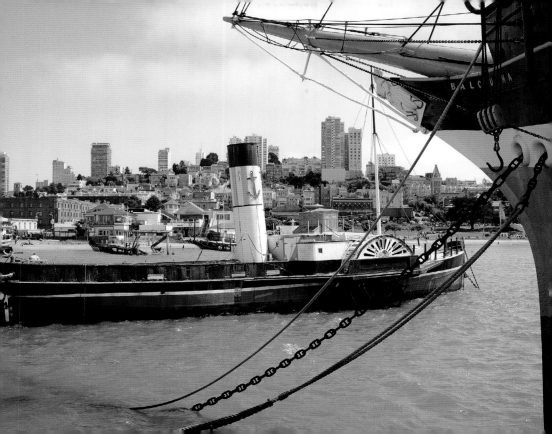

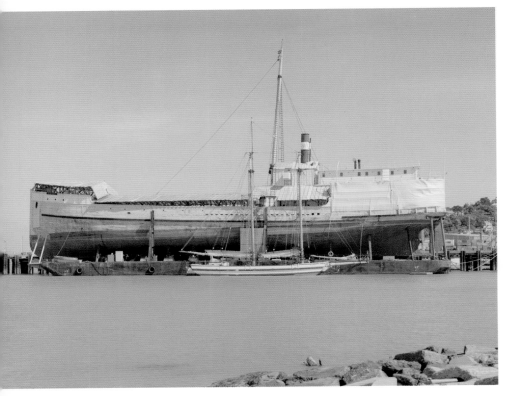

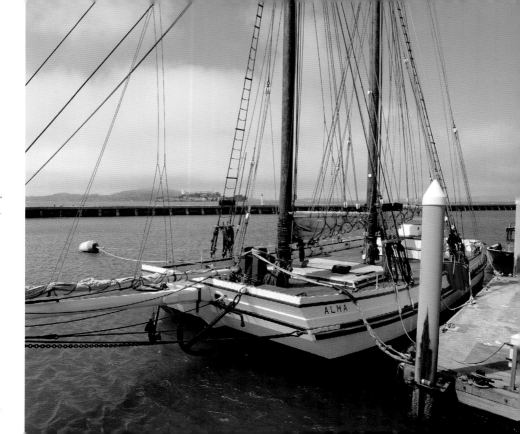

Restored Scow *Alma*, Hyde Street Pier

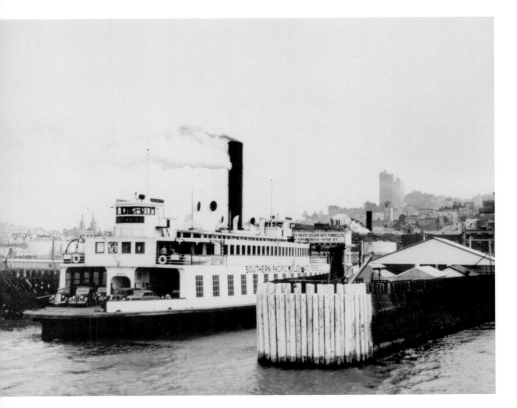

Ferry *San Mateo*, Hyde Street Pier, 1922 and Ferry *Eureka*

168

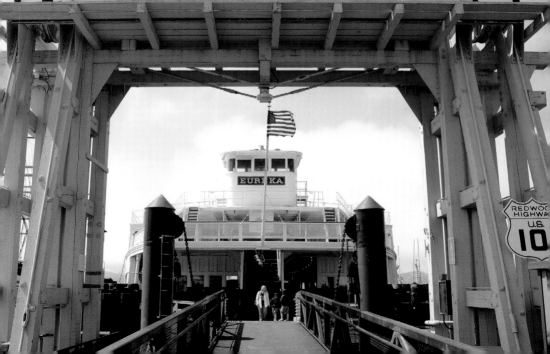

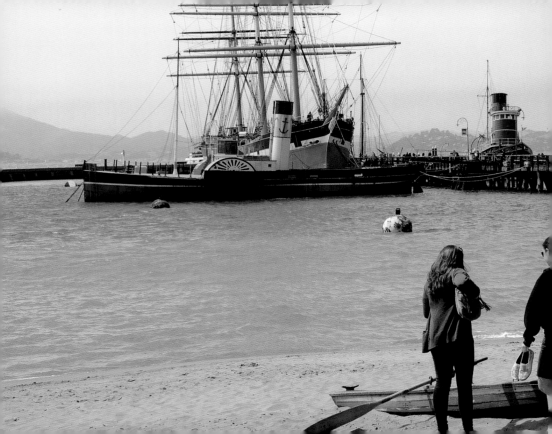

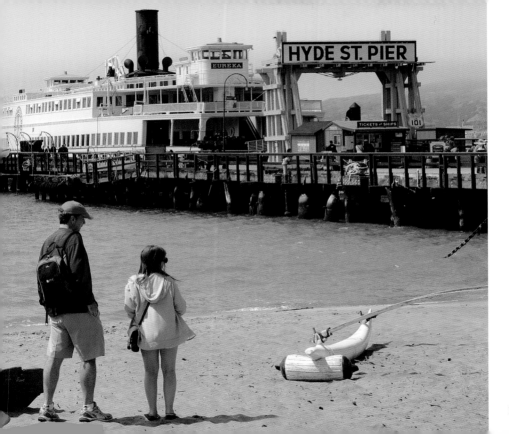

Historic ships at Hyde Street Pier

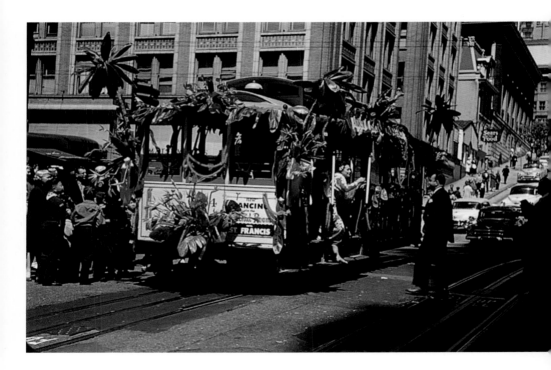

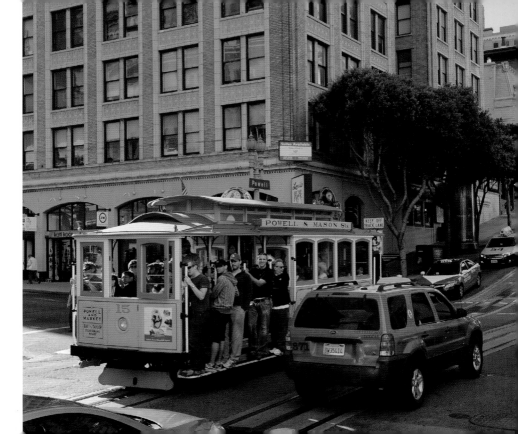

Hawaiian-themed cable car, c. 1953

LOS AN
RIVERSIDE
SANTA

GELES

BARBARA

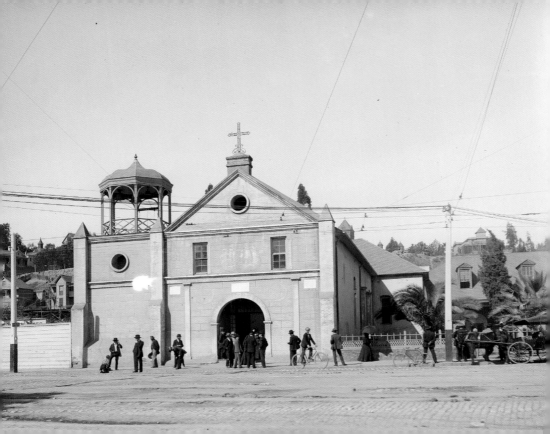

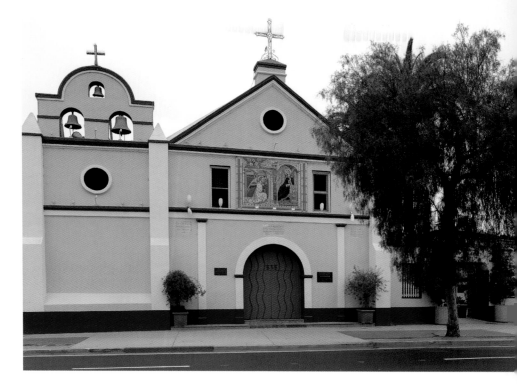

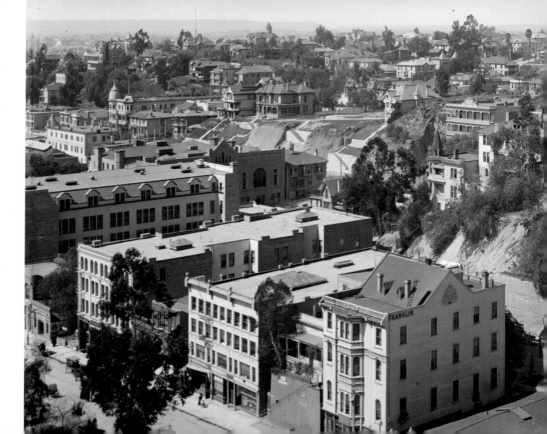

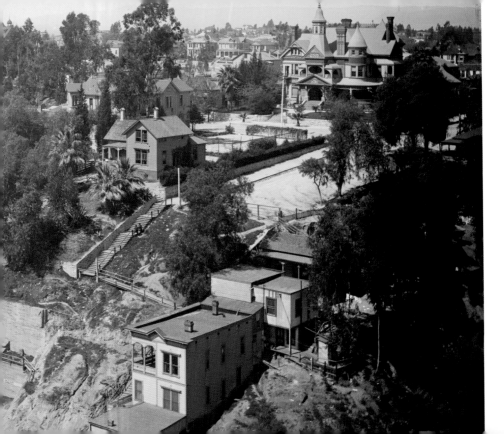

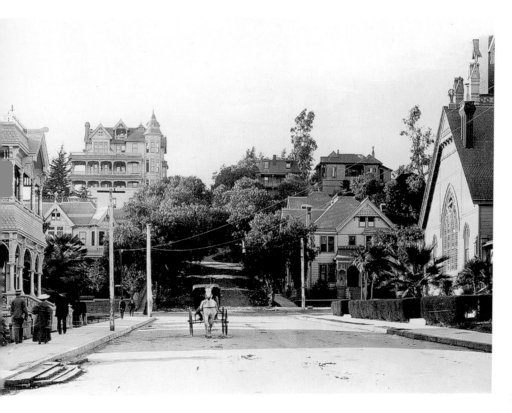

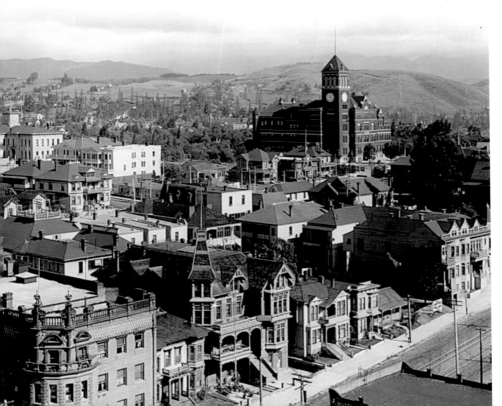

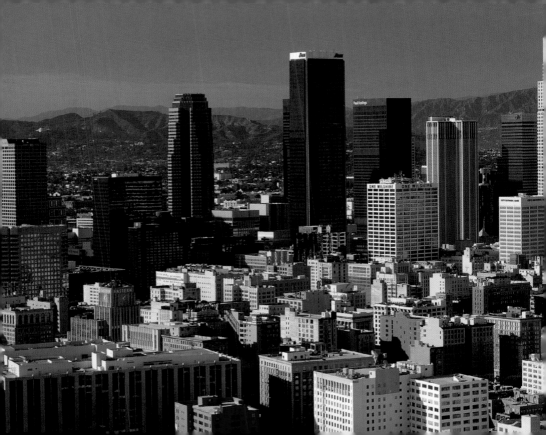

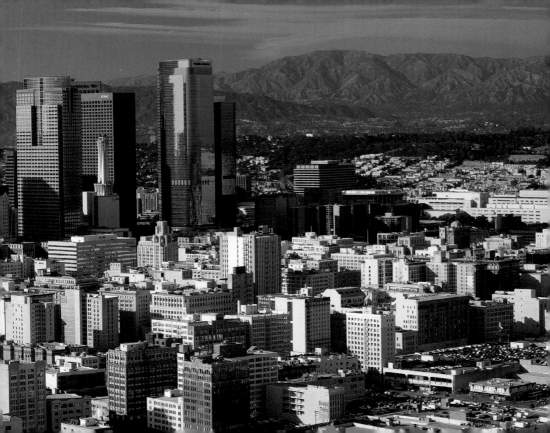

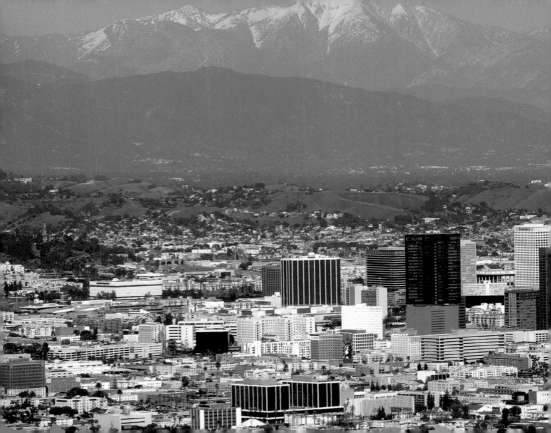

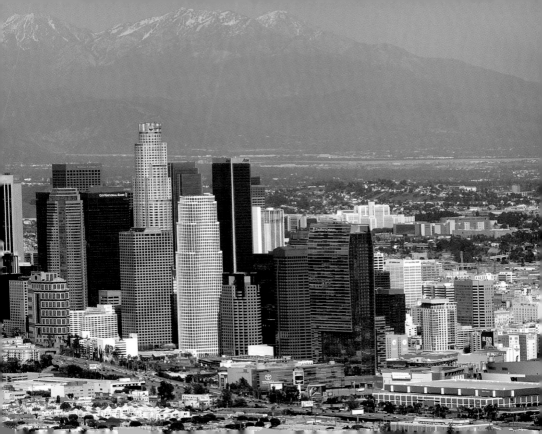

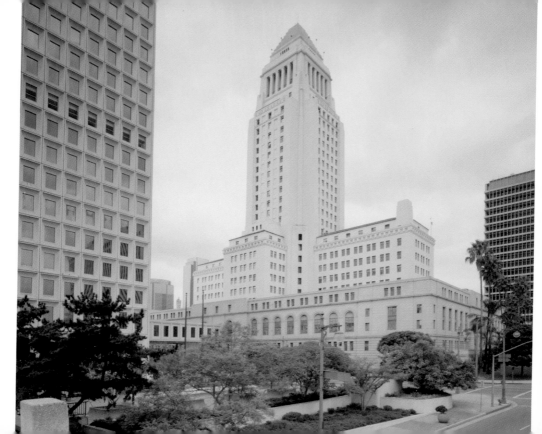

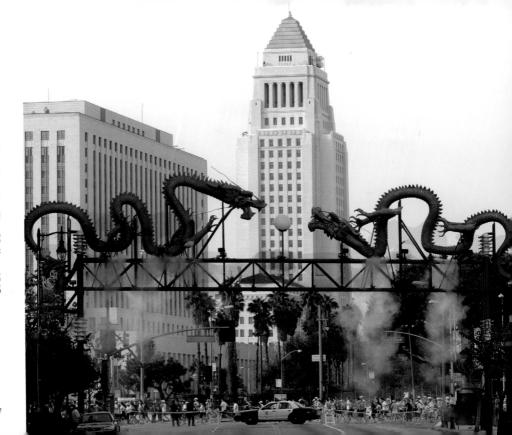

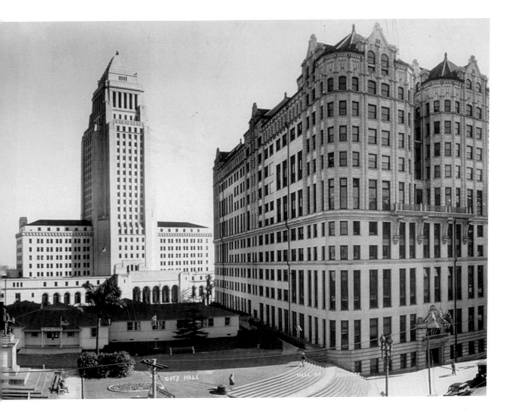

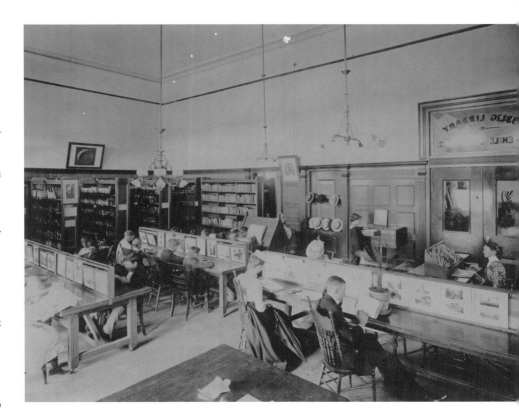

Los Angeles Public Library at Los Angeles City Hall, c. 1905

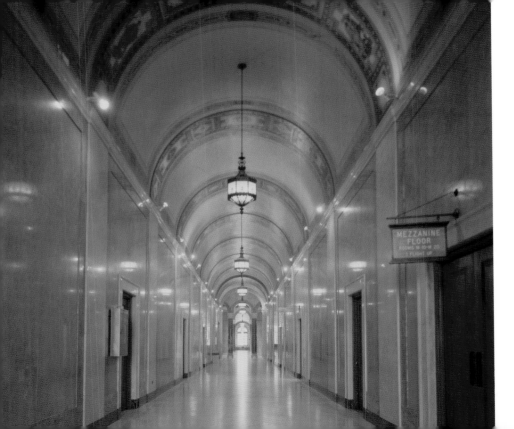

MEZZANINE
FLOOR

Los Angeles City Hall, Third Floor Council Chambers, 1997

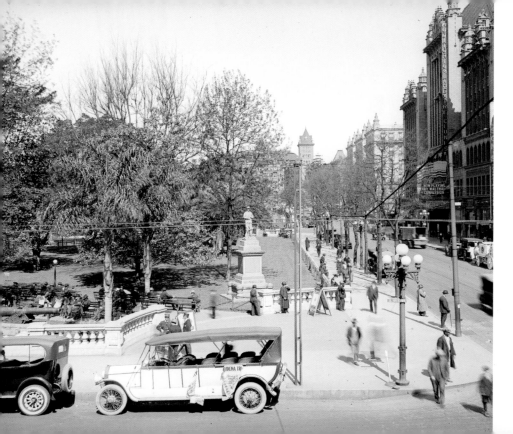

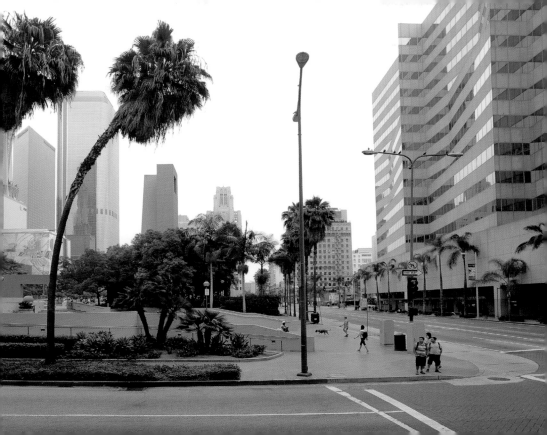

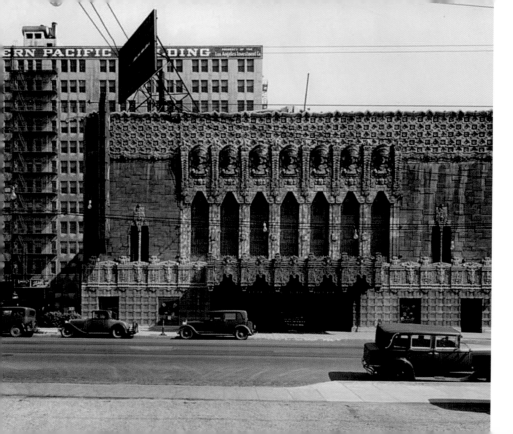

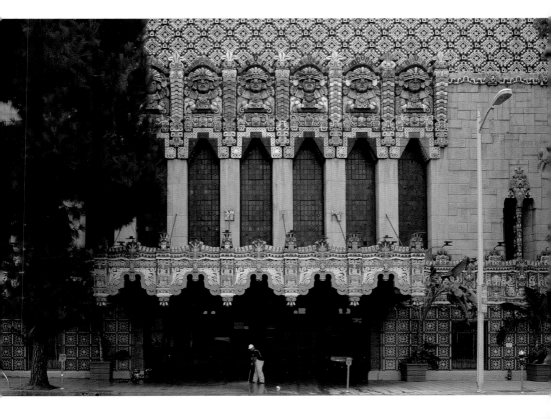

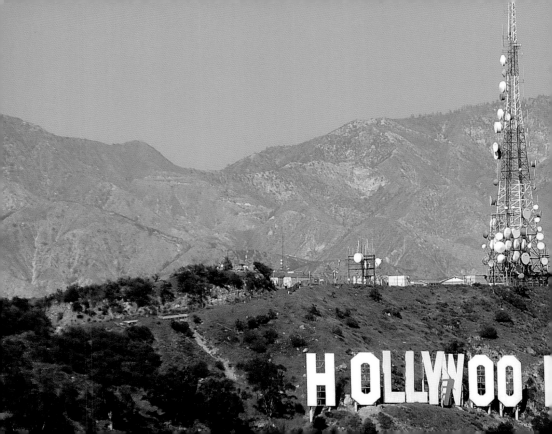

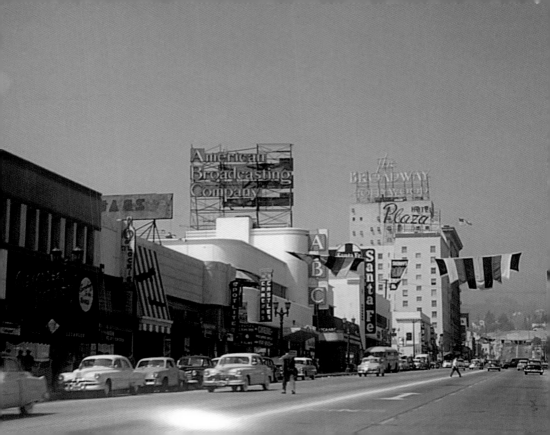

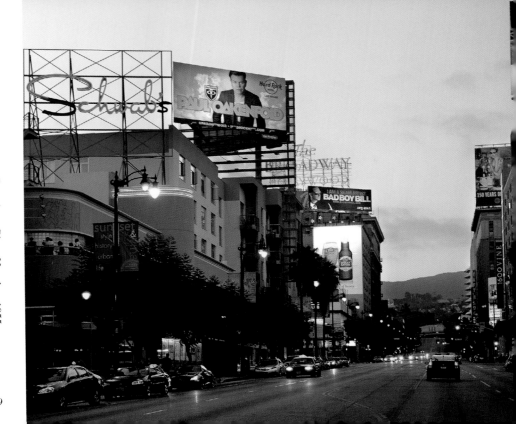

Vine Street near Broadway Plaza Hotel, c. 1955

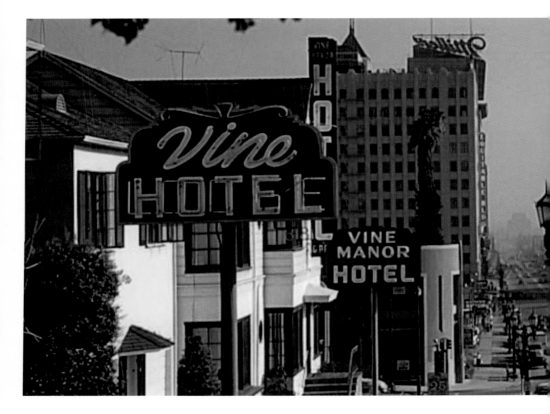

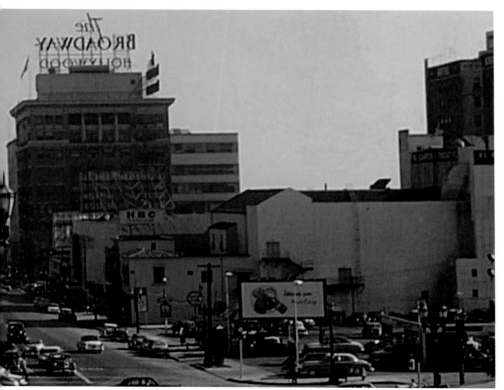

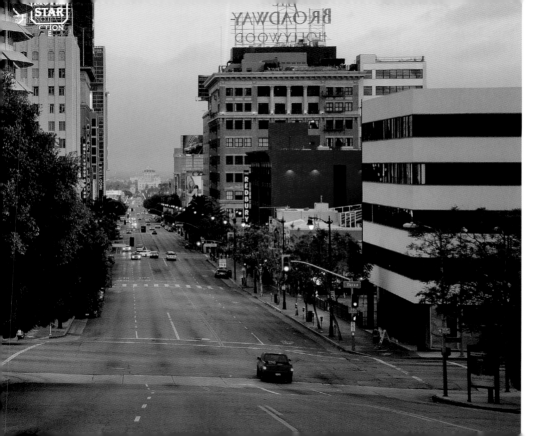

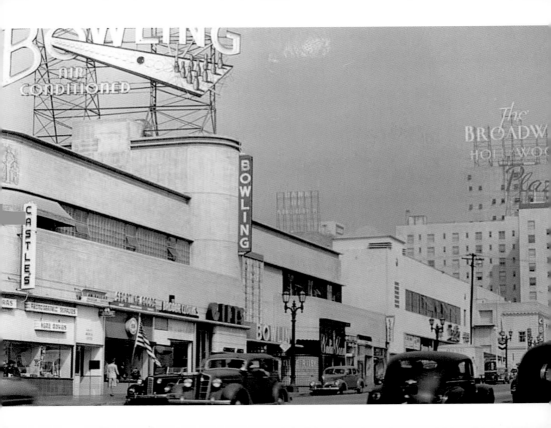

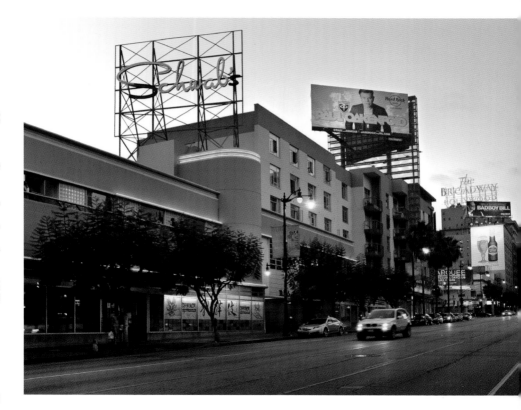

Vine near Sunset, Los Angeles, c. 1945

Coca Cola Bottling Plant, 1334 South Central Avenue, Los Angeles, c. 1974

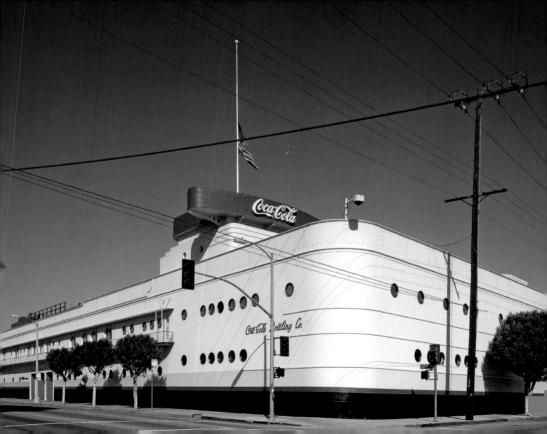

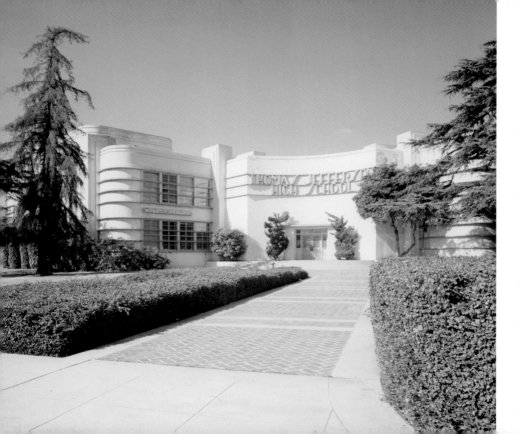

Thomas Jefferson High School, Los Angeles, c. 1970

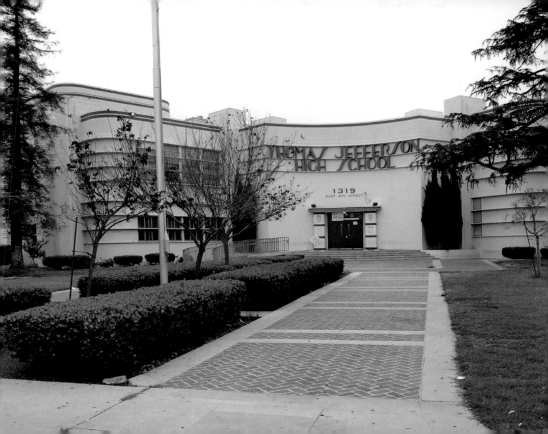

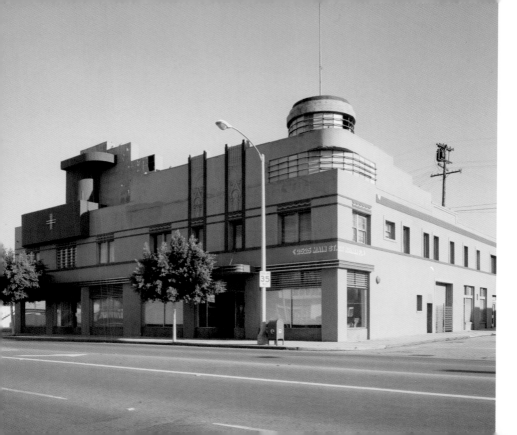

2525 Main Street, Los Angeles, c. 1970

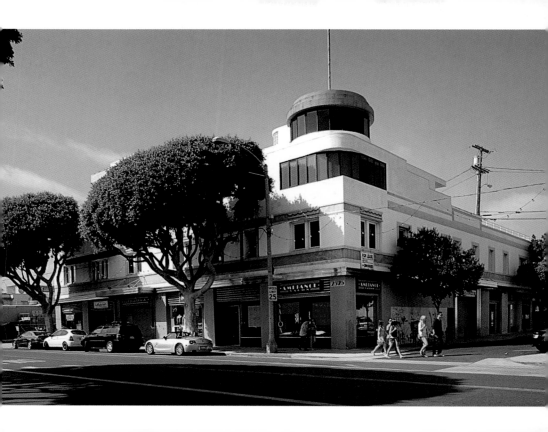

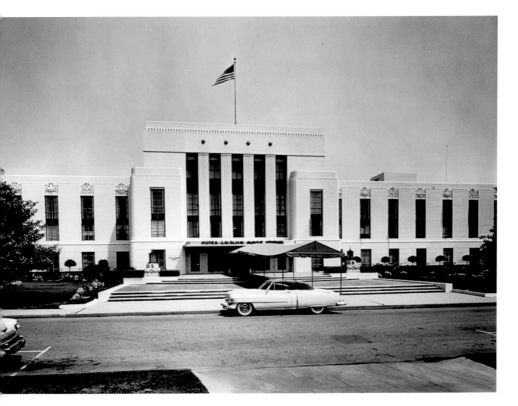

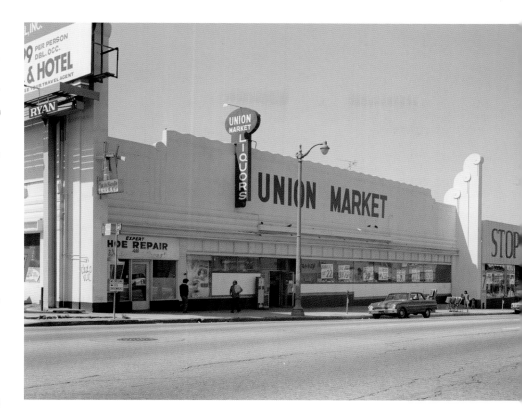

Union Market, 1530–1536 West Sixth Street, Los Angeles, c. 1971

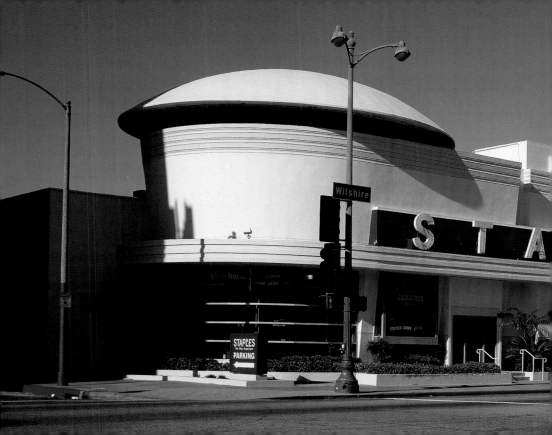

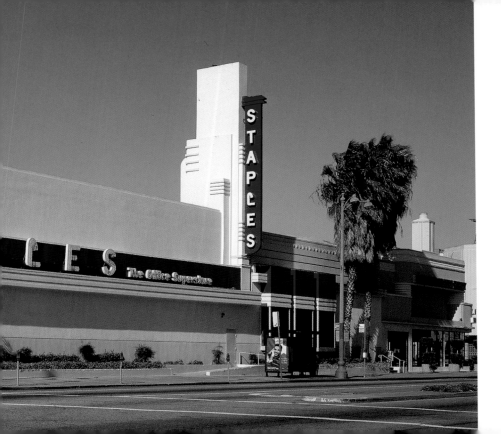

The (1936) Merle Norman Building, Los Angeles

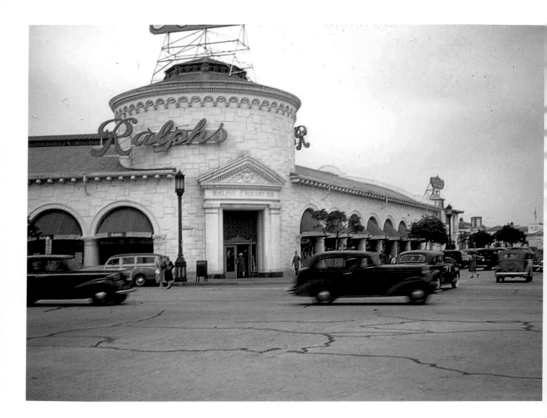

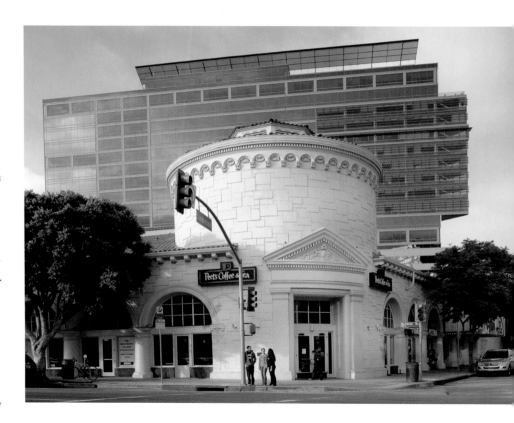

Ralph's, Westwood Village, c. 1954

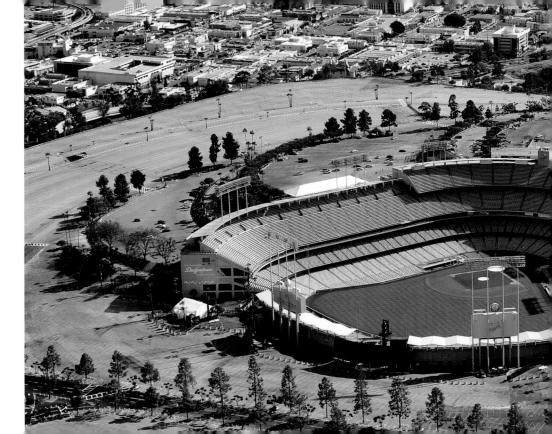

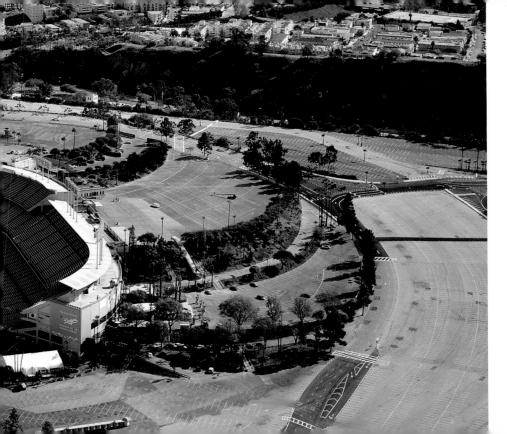

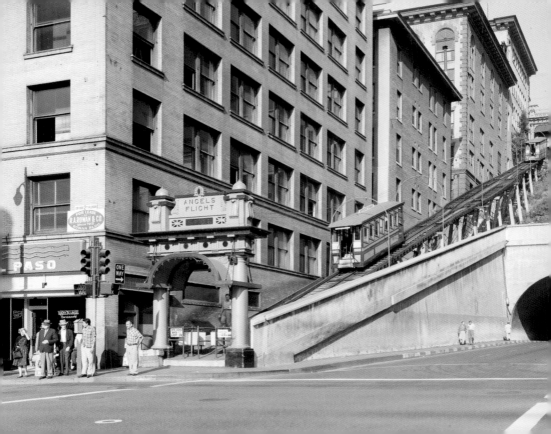

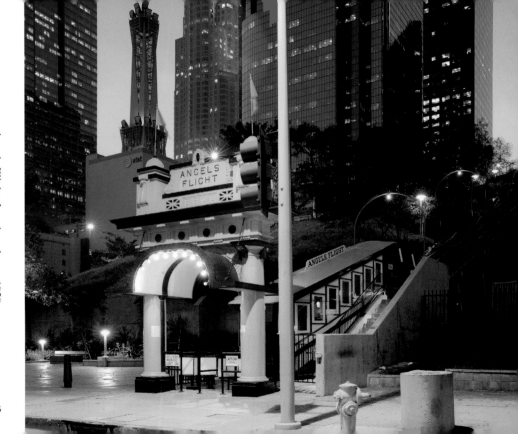

Angels Flight, Los Angeles, c. 1959

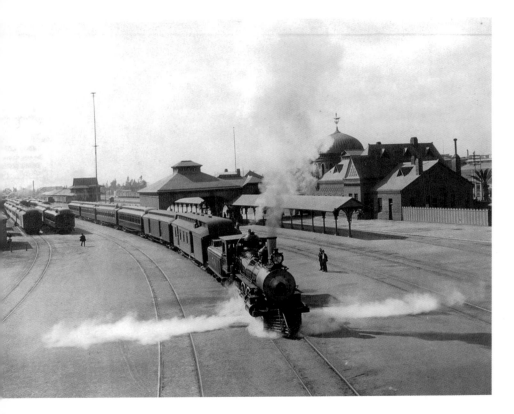

224

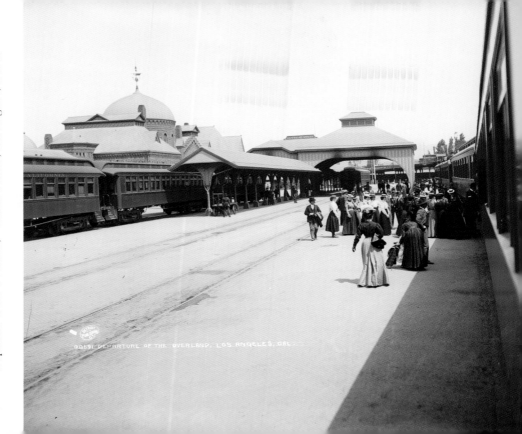

99691 DEPARTURE OF THE OVERLAND, LOS ANGELES, CAL.

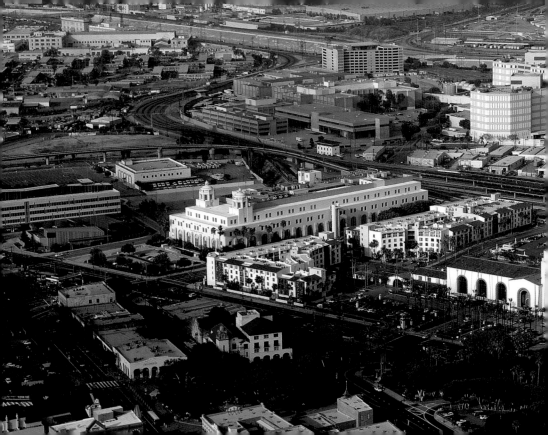

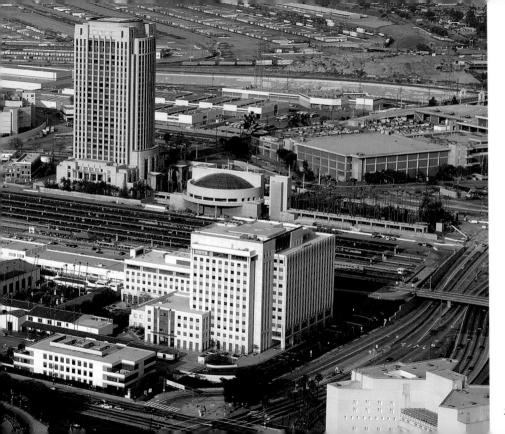

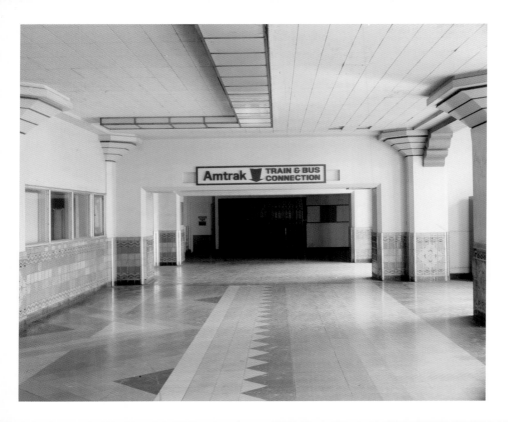

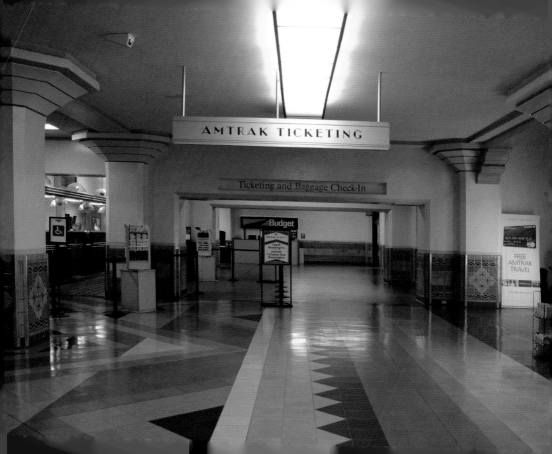

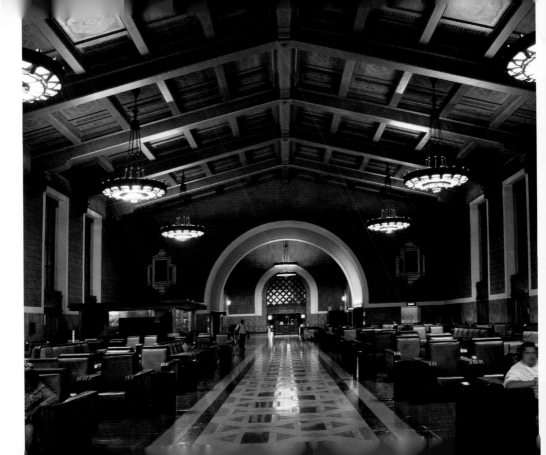

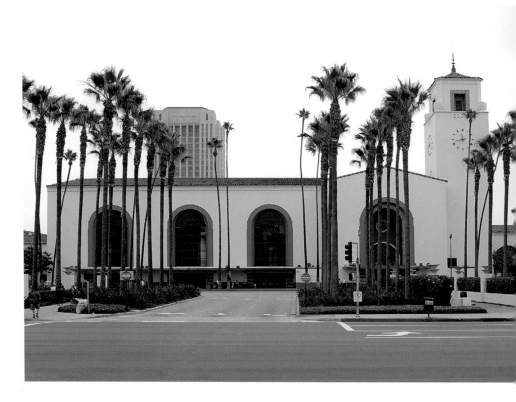

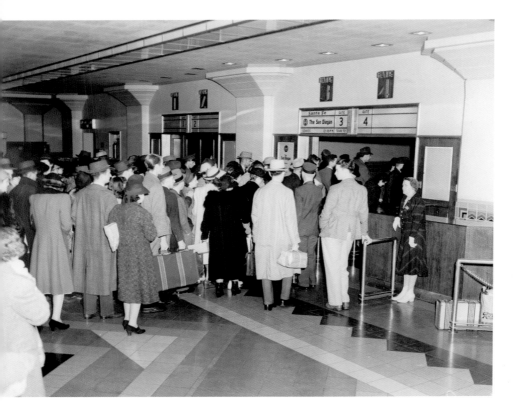

Union Station, Los Angeles, c. 1947

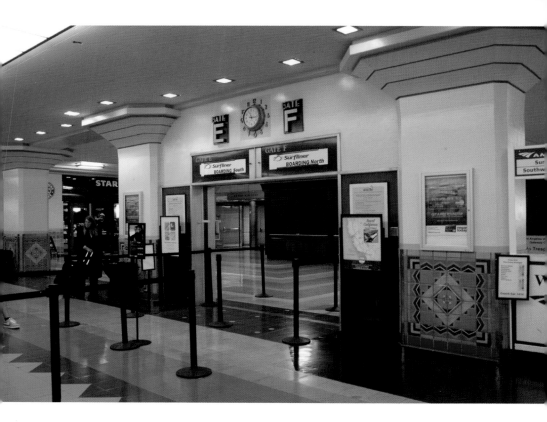

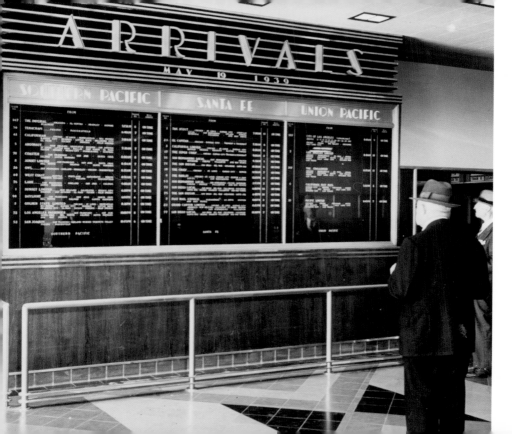

Union Station, Los Angeles, c. 1947

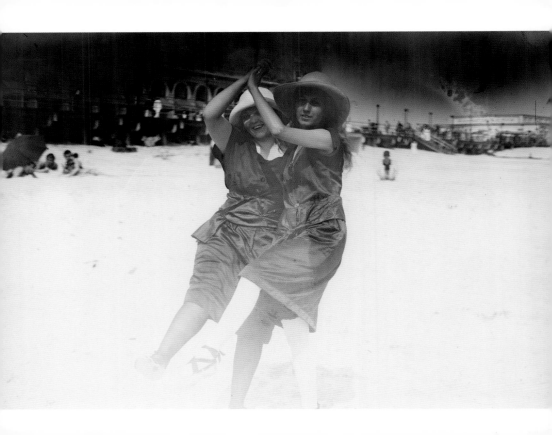

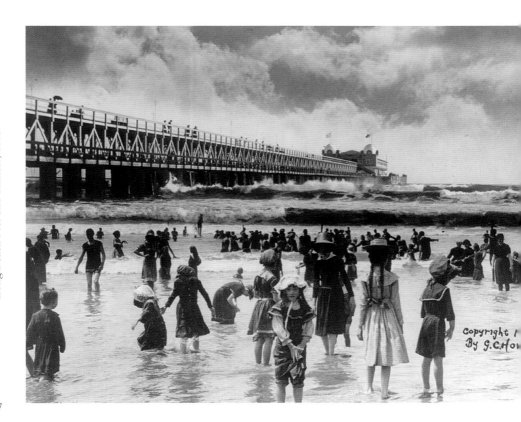

Long Beach Pier and bathers, 1905

Copyright 1 By G.C.Ho[...]

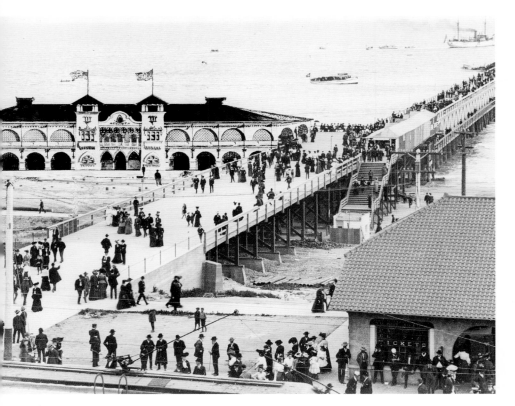

Long Beach Pier and promenade, 1905

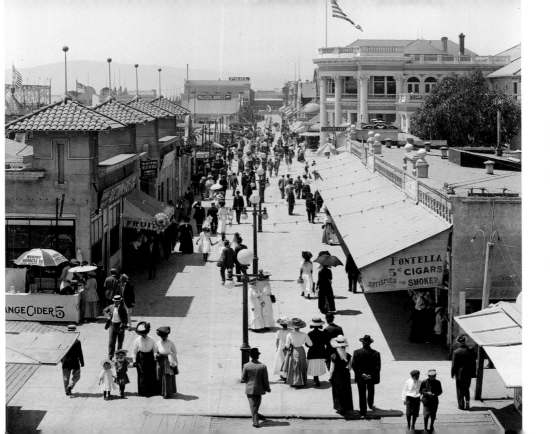

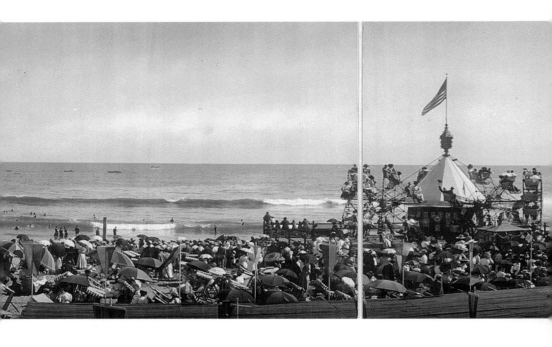

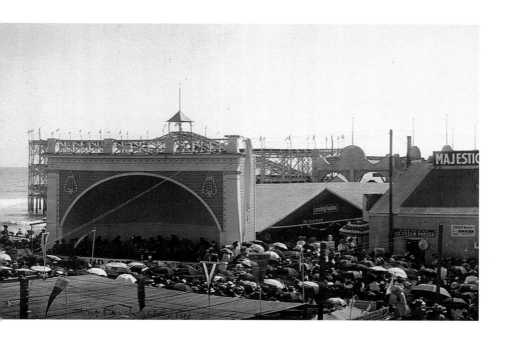

Long Beach auditorium and Majestic Dance Hall, 1909

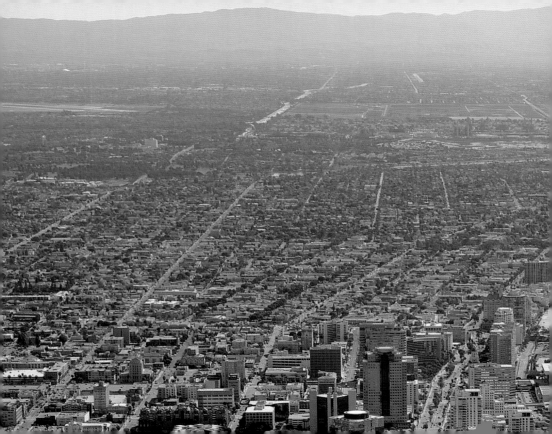

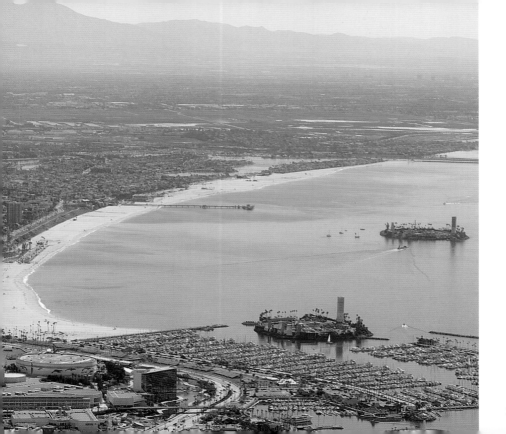

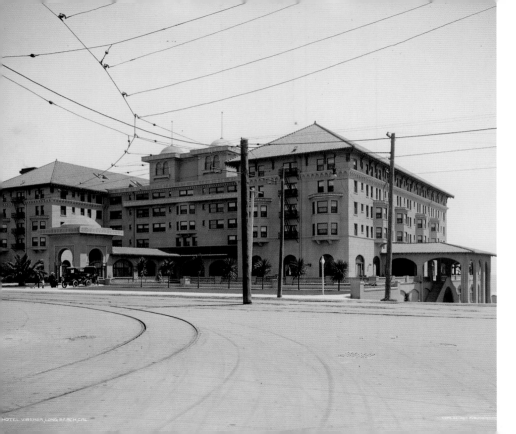

HOTEL VIRGINIA, LONG BEACH, CAL.

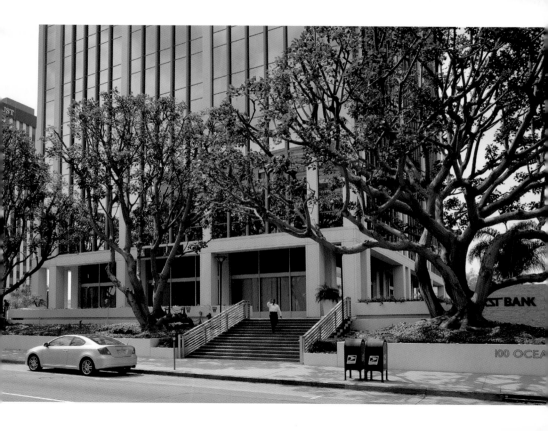

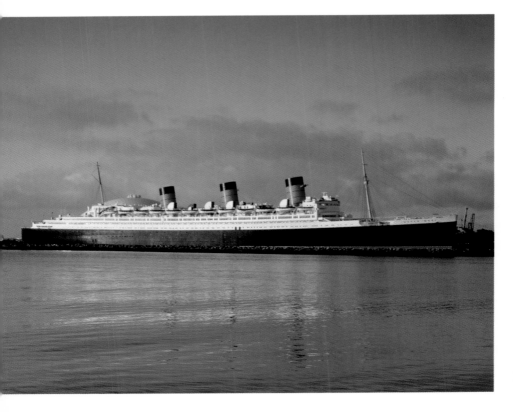

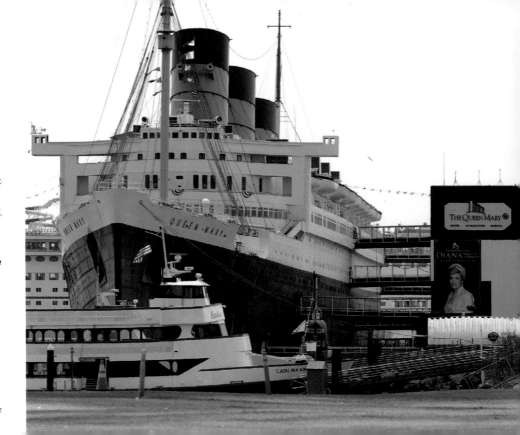

RMS *Queen Mary*, Long Beach

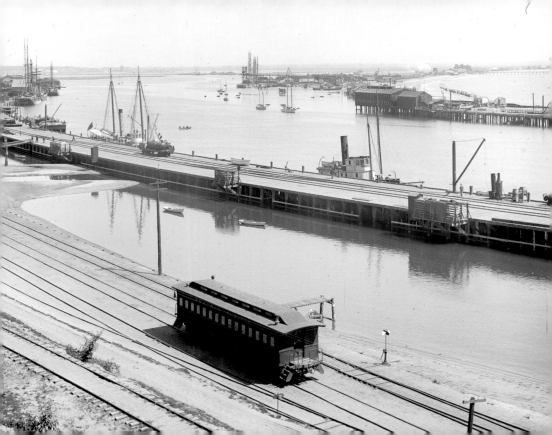

San Pedro harbor, c. 1900

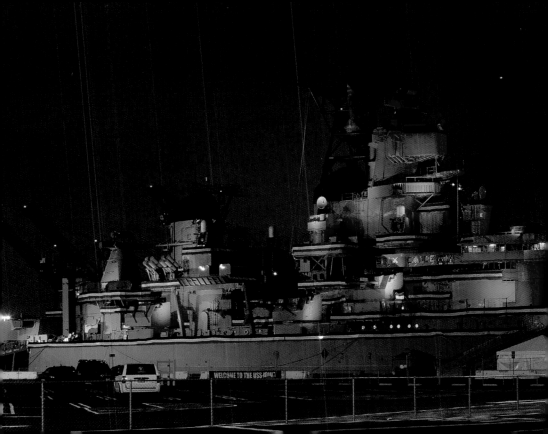

USS *Iowa*, San Pedro

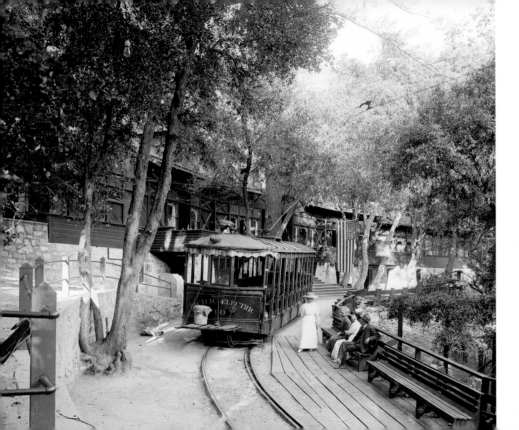

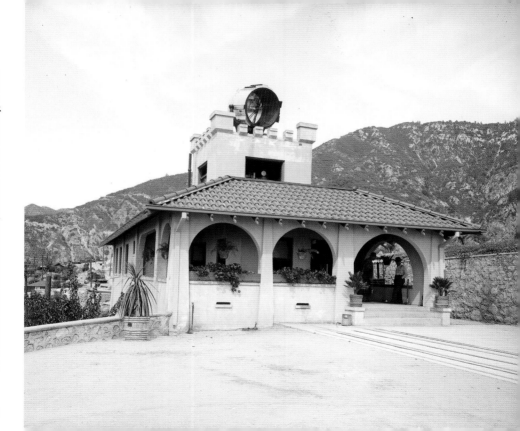

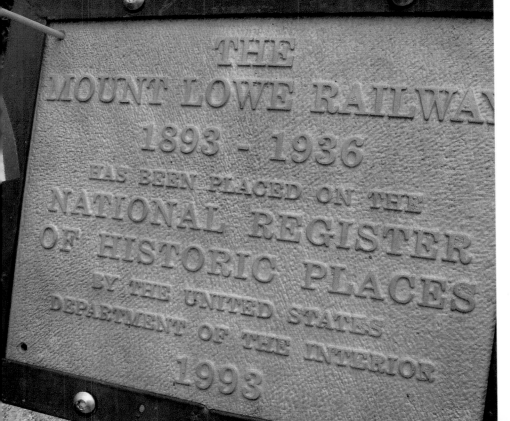

THE
MOUNT LOWE RAILWAY
1893 - 1936
HAS BEEN PLACED ON THE
NATIONAL REGISTER
OF HISTORIC PLACES
BY THE UNITED STATES
DEPARTMENT OF THE INTERIOR
1993

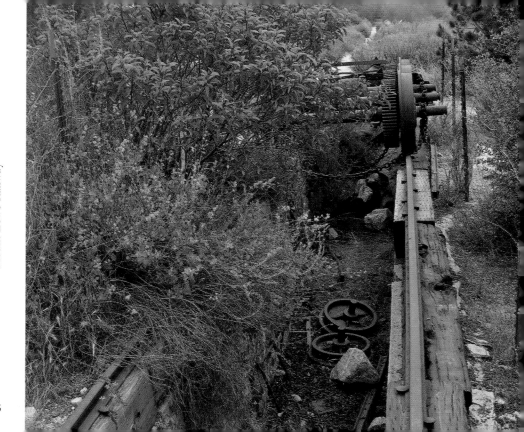

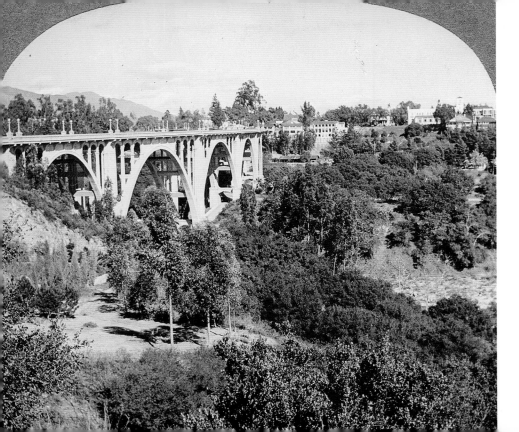

The Arroyo Seco Bridge, Pasadena, c. 1926

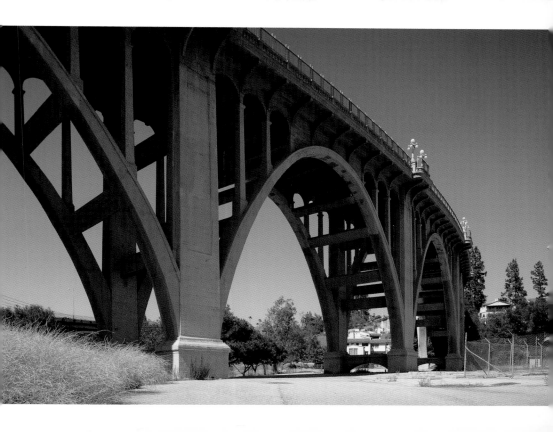

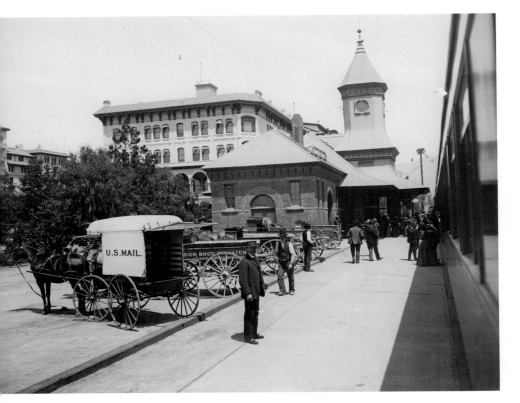

Railway station, Pasadena, c. 1904

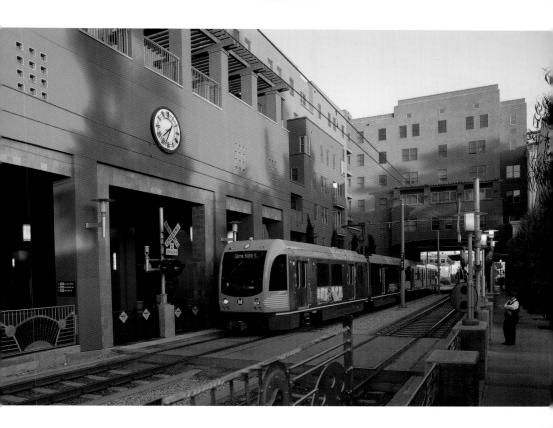

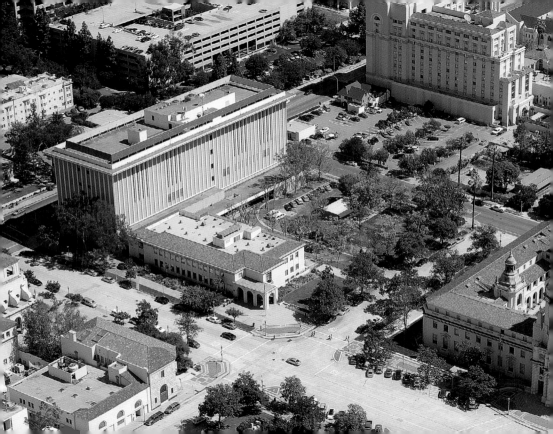

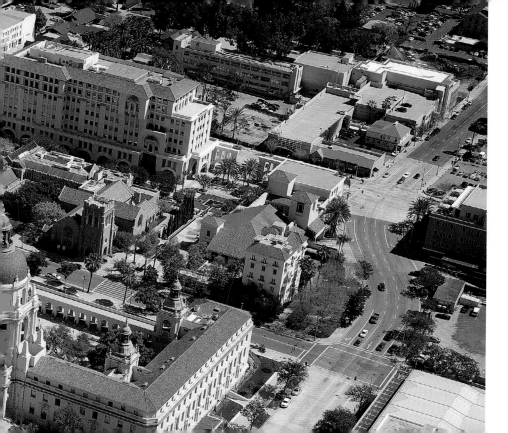

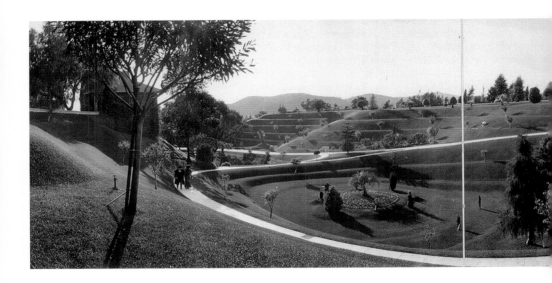

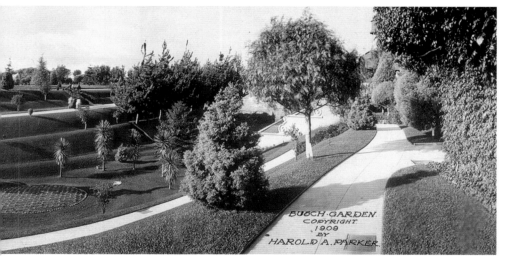

BUSCH·GARDEN
COPYRIGHT
1909
BY
HAROLD A. PARKER

Busch Garden, Pasadena, 1909

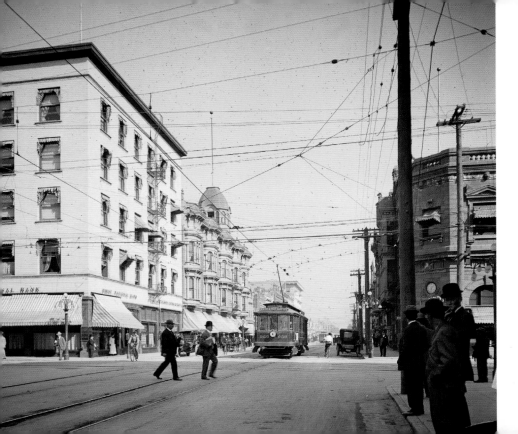

264

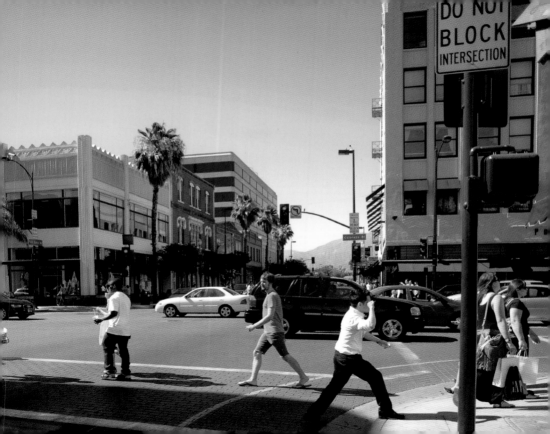

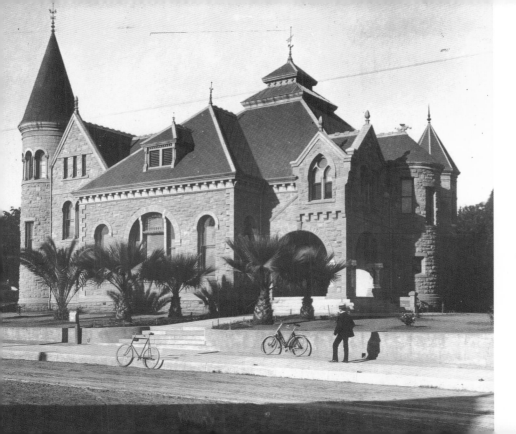

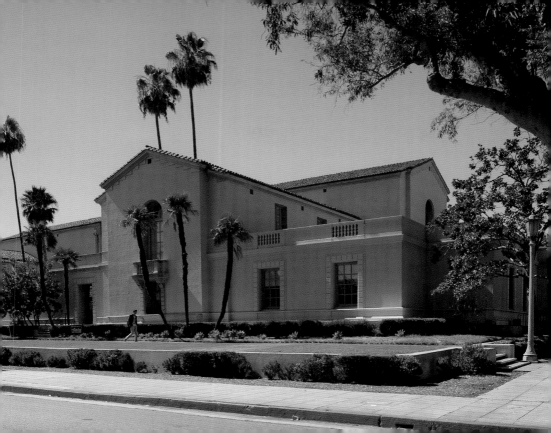

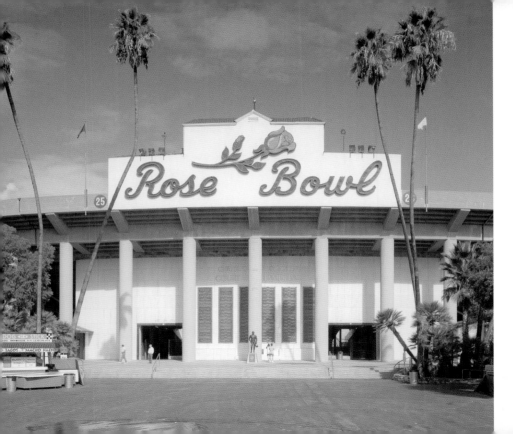

Rose Bowl, Pasadena, c. 1990

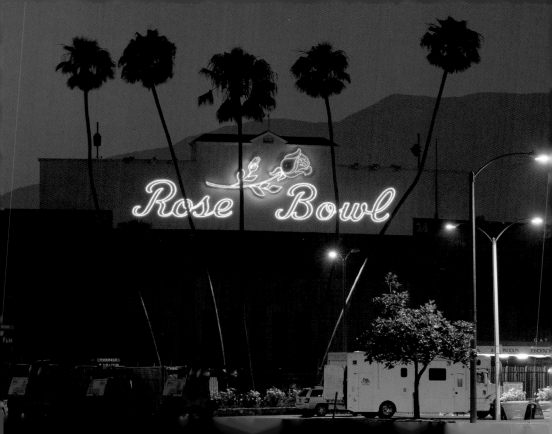

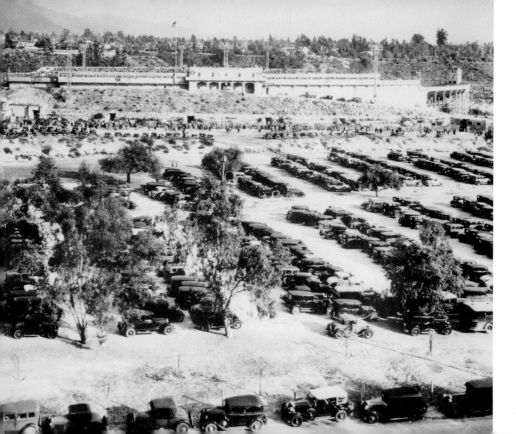

Rose Bowl, Pasadena, 1934

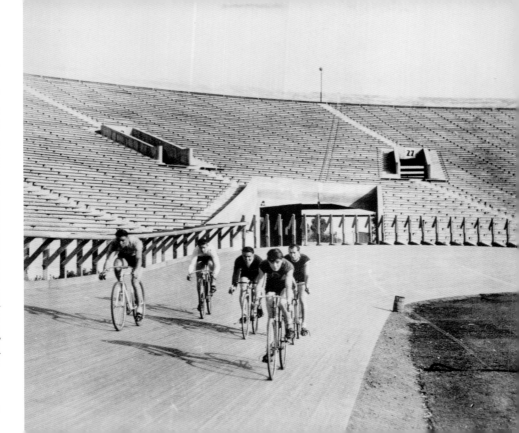

Olympic bicycle track, view south, Rose Bowl, Pasadena, 1932

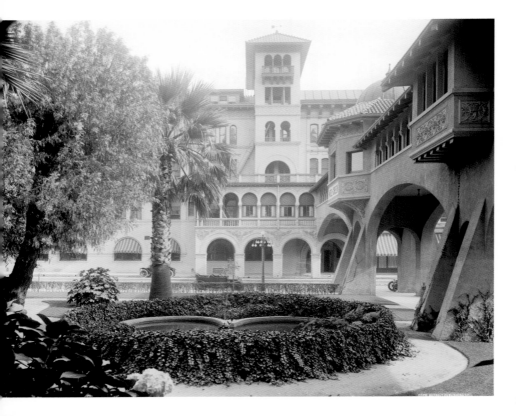

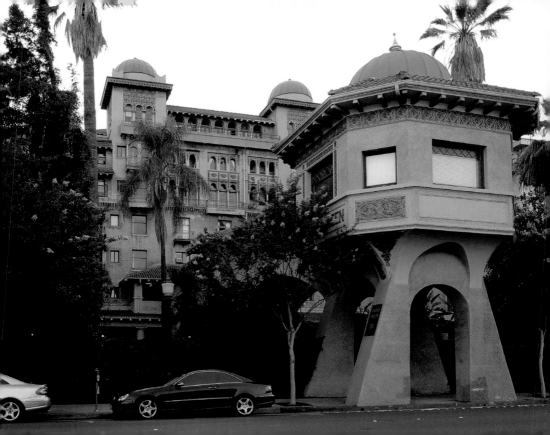

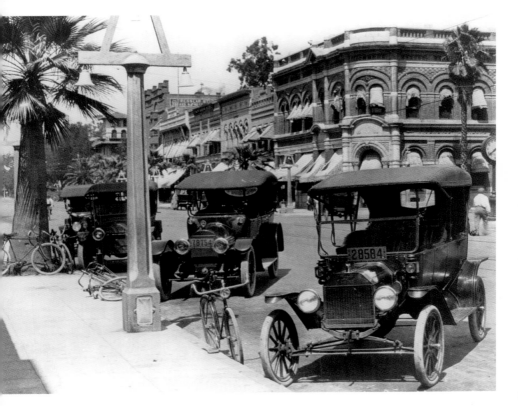

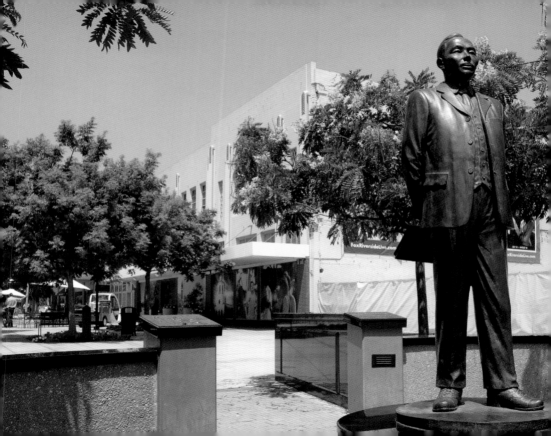

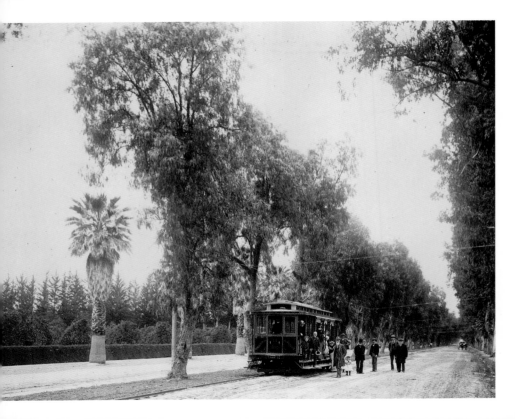

276

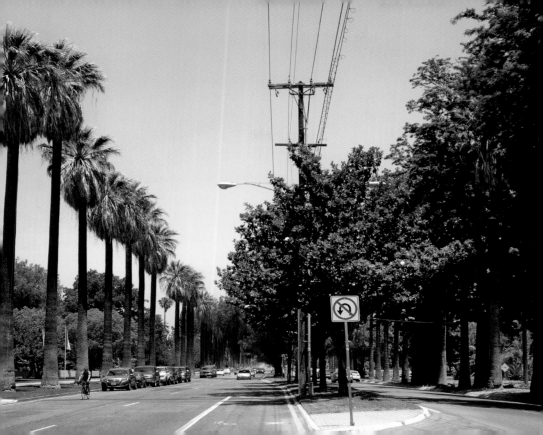

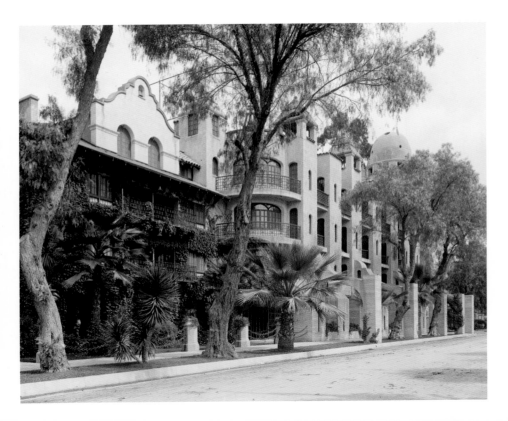

Glenwood Mission Inn, Riverside, c. 1910

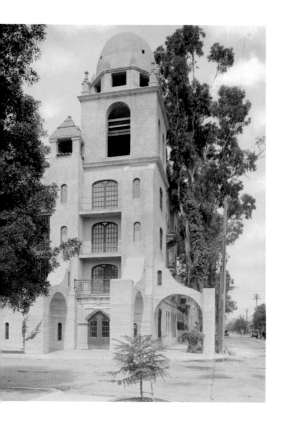
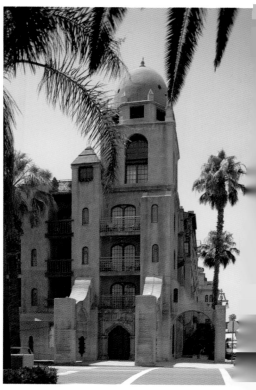

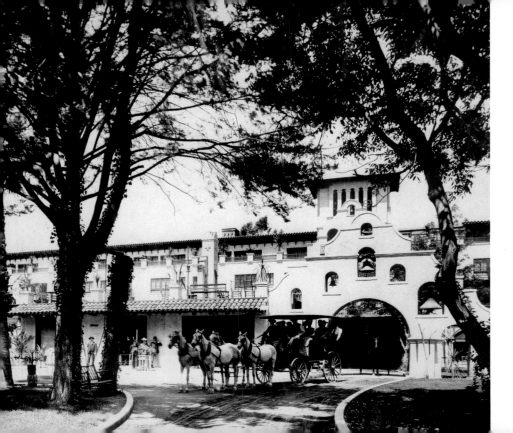

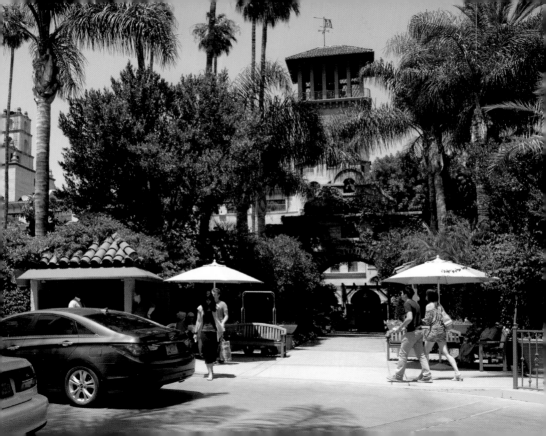

Union Pacific railroad bridge across Santa Anna River, Riverside, c. 1904

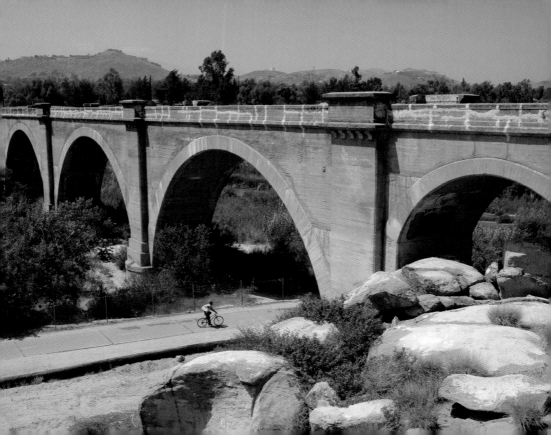

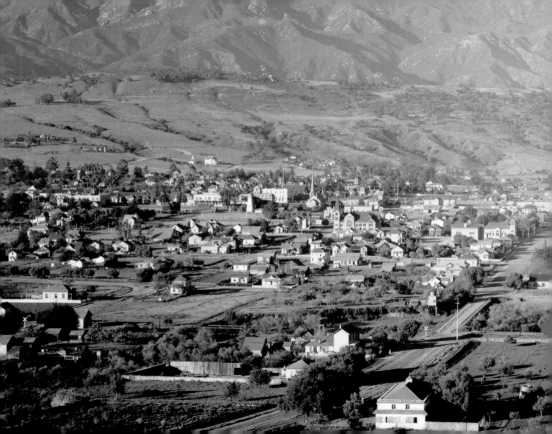

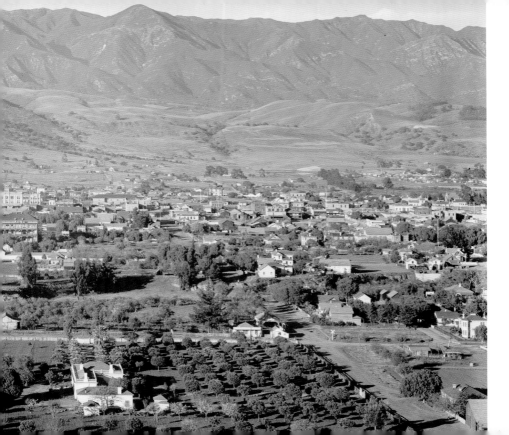

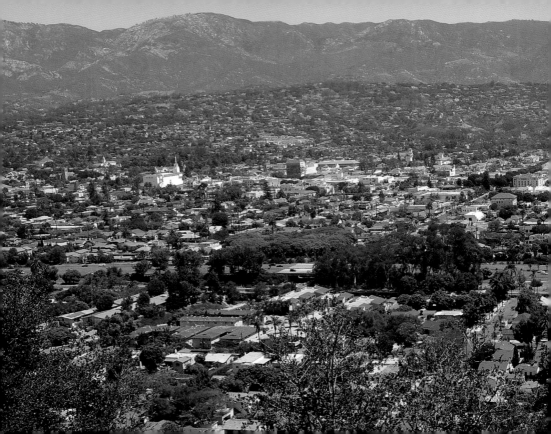

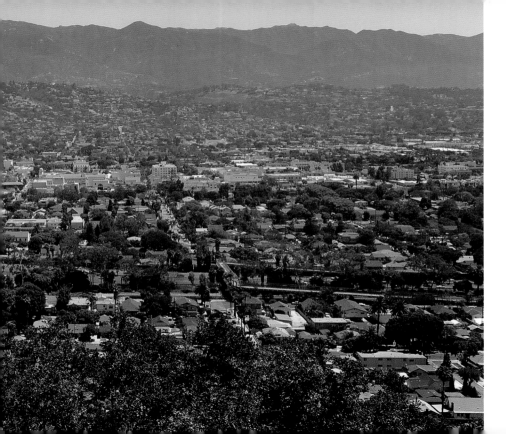

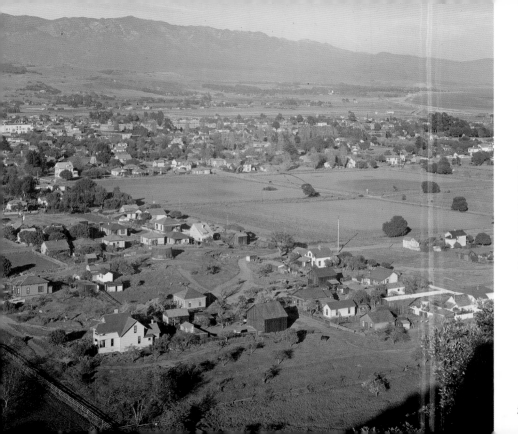

Santa Barbara, c. 1906

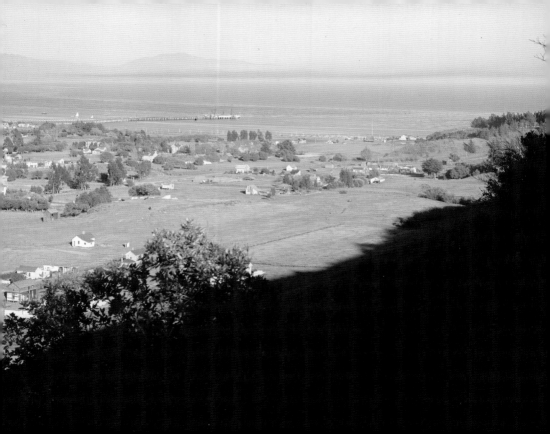

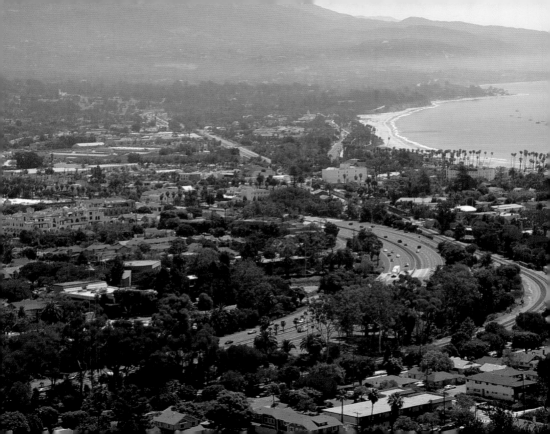

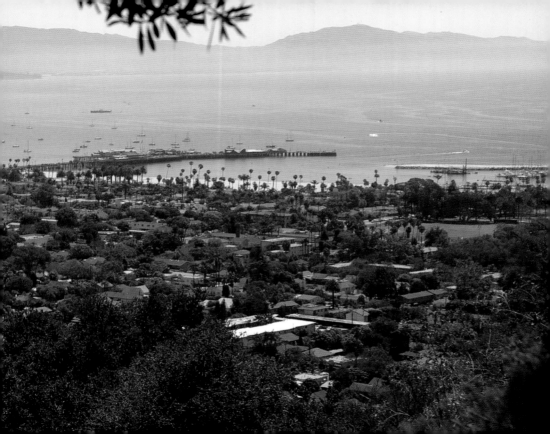

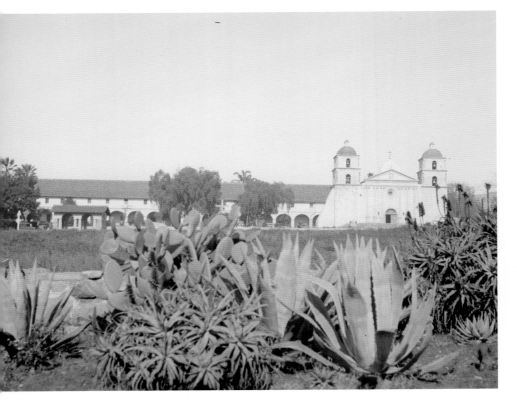

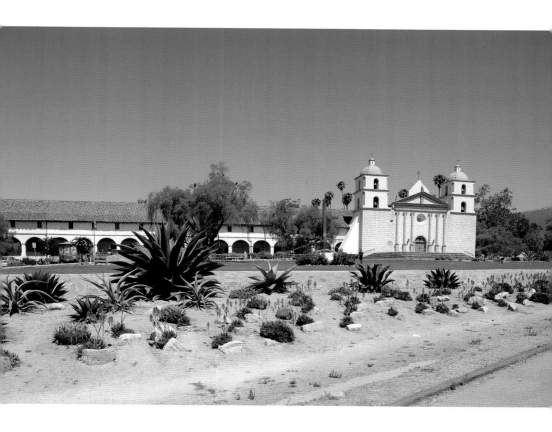

Mission Santa Barbara, 2201 Laguna Street, Santa Barbara, 1917

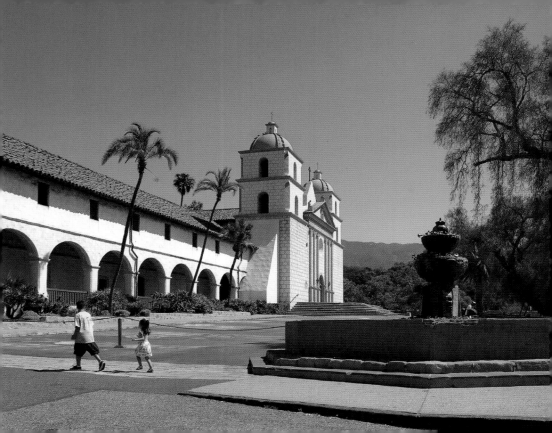

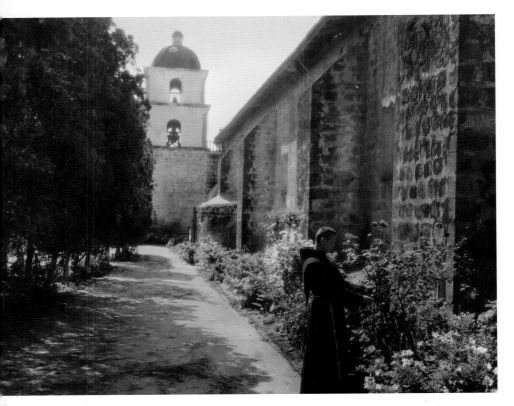

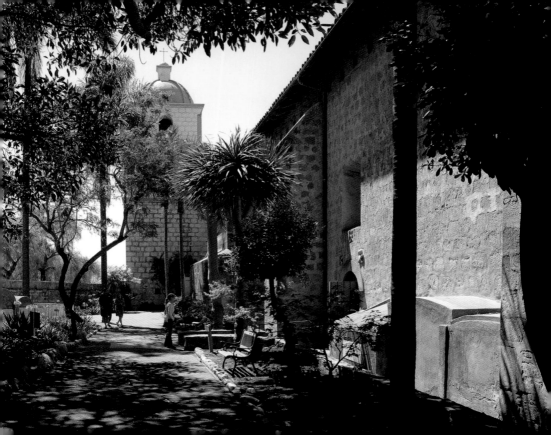

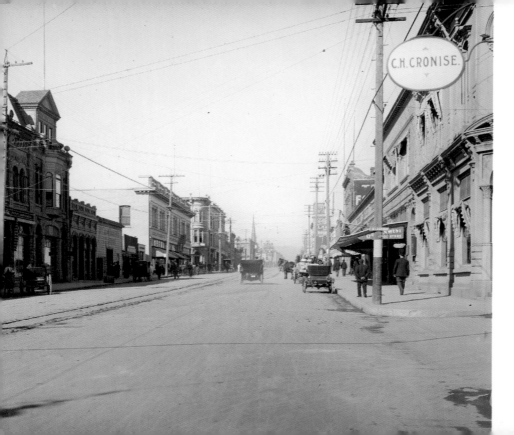

C.H.CRONISE.

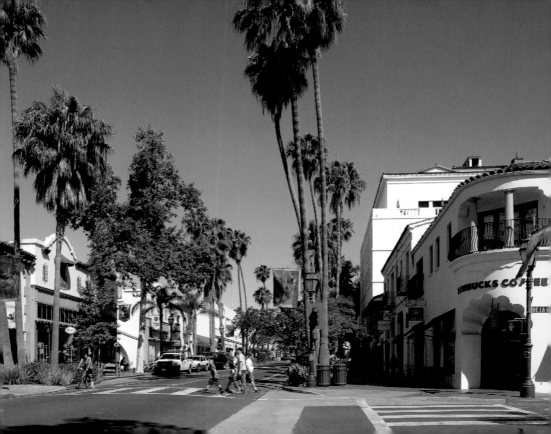

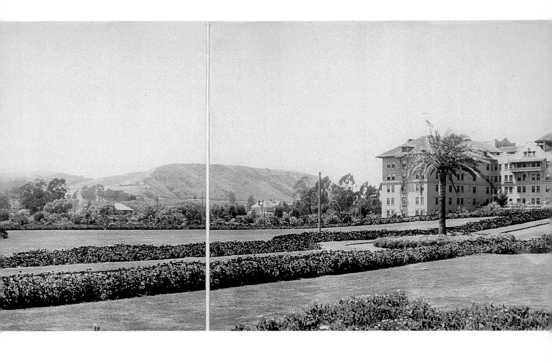

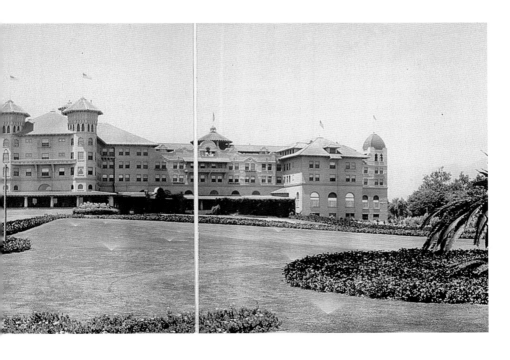

Hotel Potter, Santa Barbara, 1909

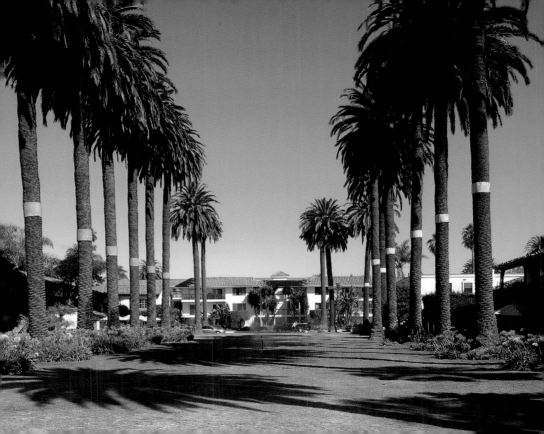

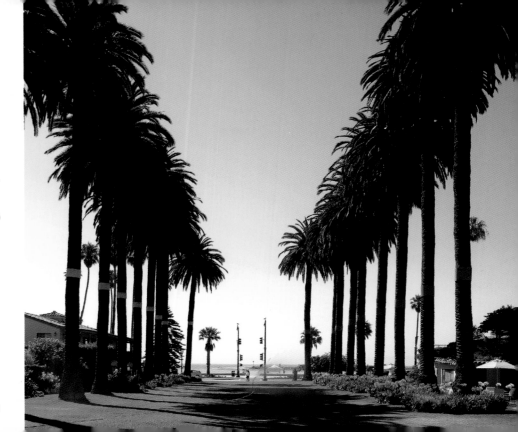

Site of Hotel Potter's grounds, Santa Barbara

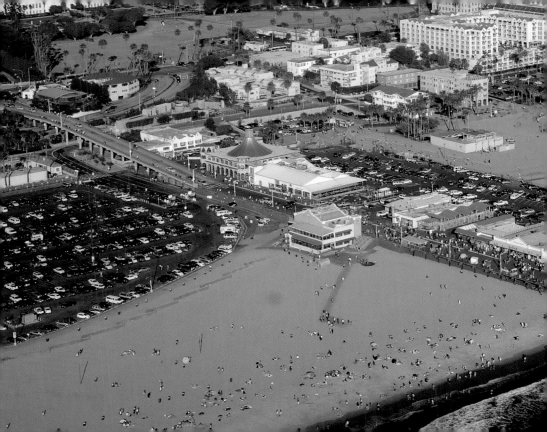

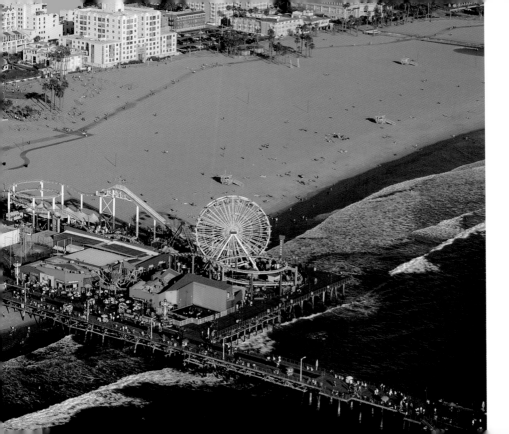

Santa Monica Pier, 2009

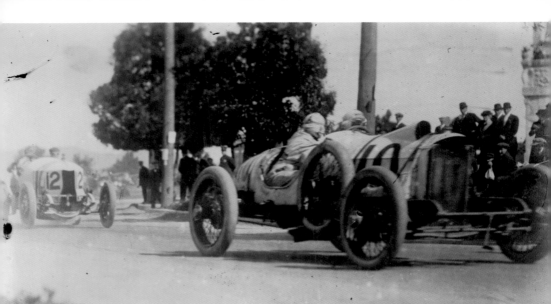

"DEATH" CURVE, A RIGHT ANGLED
TURN WHERE DANGER LURKS

AVENUE

BRIDGE

WILSHIRE

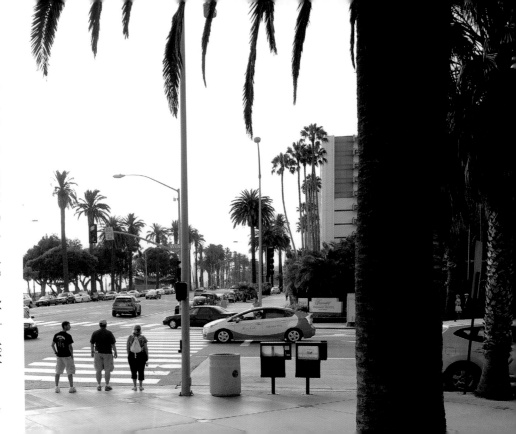

"Death Curve" on Wilshire Boulevard, Santa Monica, 1914

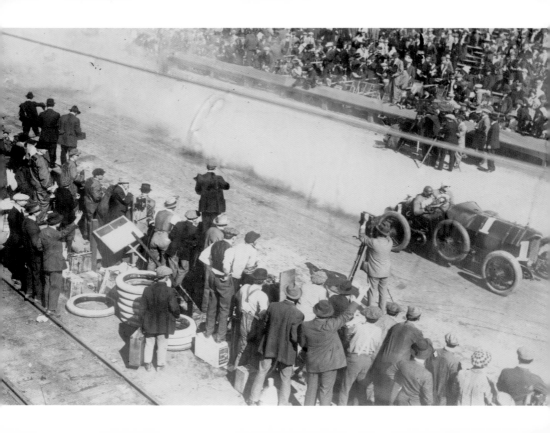

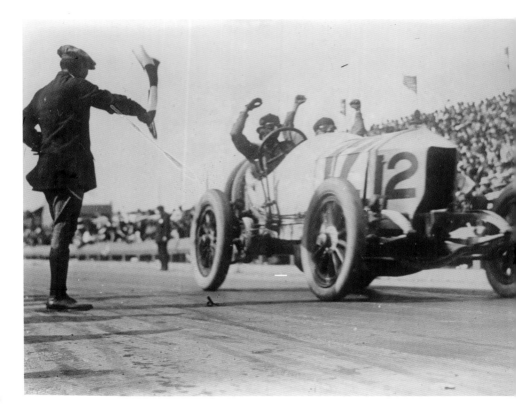

The start and finish of the Vanderbilt Cup race, Santa Monica, 1914

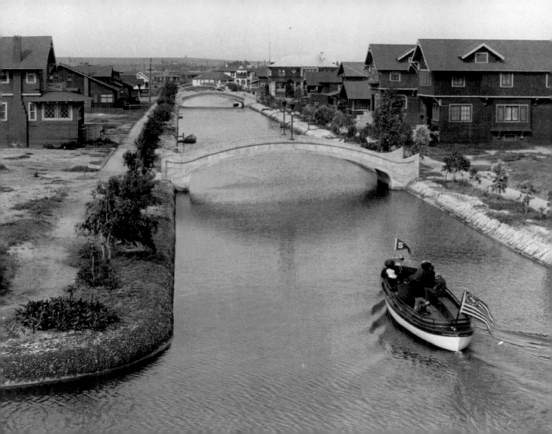

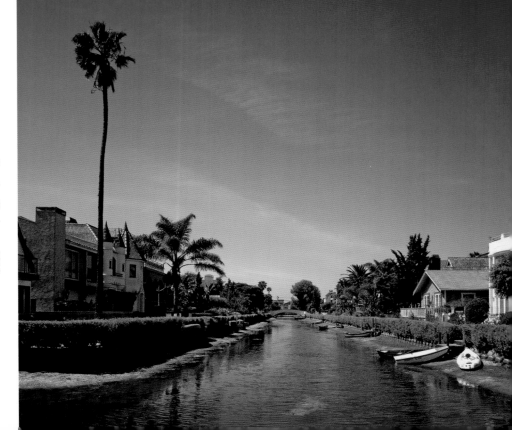

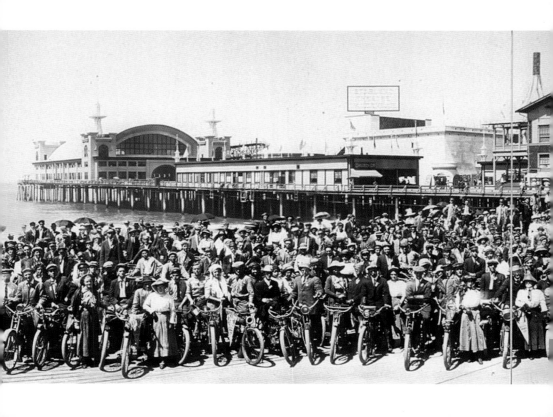

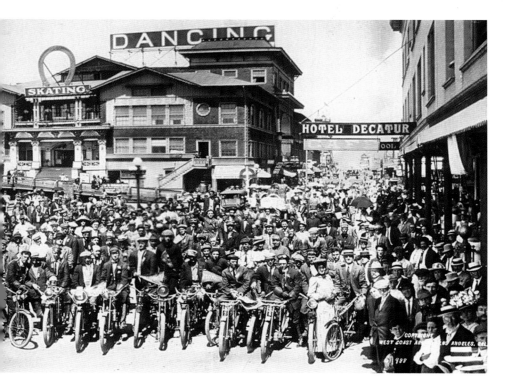

Los Angeles Motorcycle Club, Venice, 1911

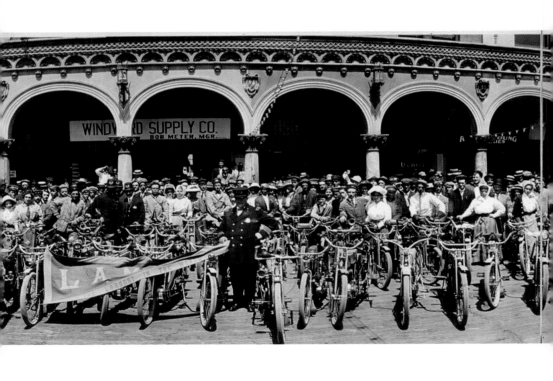

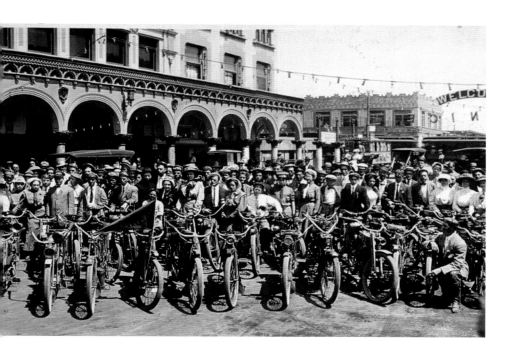

Los Angeles Motorcycle Club, Venice, 1911

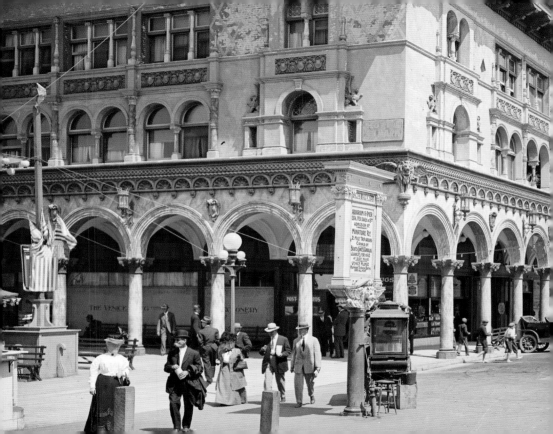

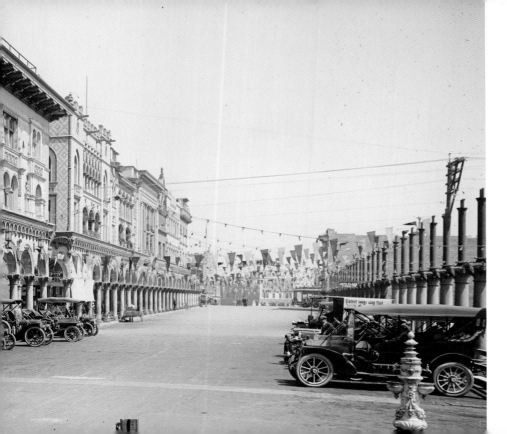

Hotel St. Mark, Venice, c. 1910

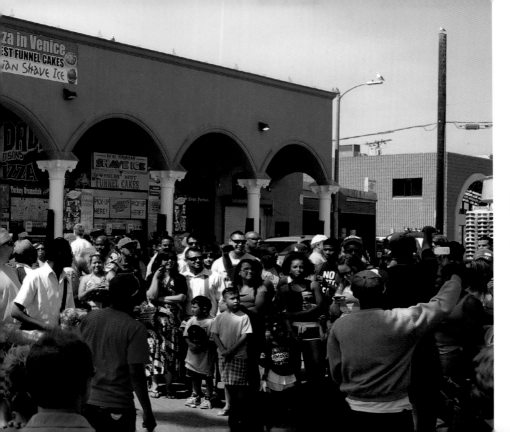

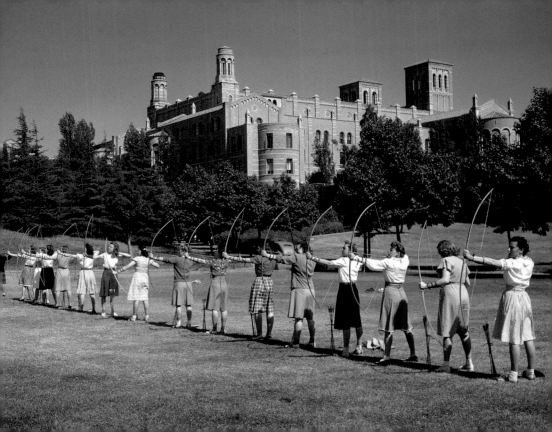

Archery practice in front of Royce Hall, UCLA, Los Angeles, c. 1952

CATA

LINA
ISLAND

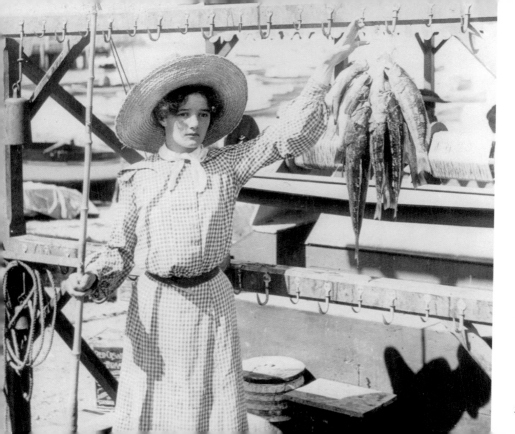

A "fishermaiden and her catch," Avalon Harbor, 1906

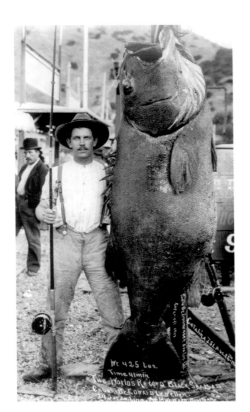

Edward Llewellen with World Record Black Sea Bass, (425 lbs.), 1903

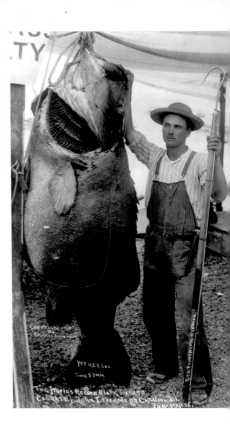

John I. Perkins with World Record Black Sea Bass, (428 lbs.), 1905

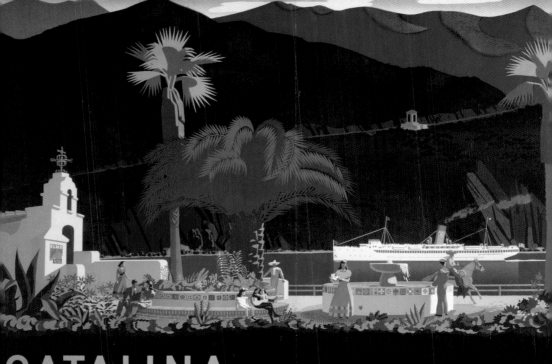

CATALINA

Now see Santa Catalina the Scenic Ri...

of the USA ...yet only a short delightful voyage from Los An...

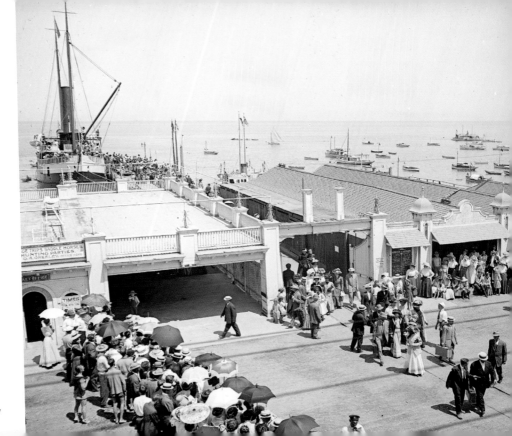

Catalina Island poster, c. 1935 and visitors arriving, c. 1910

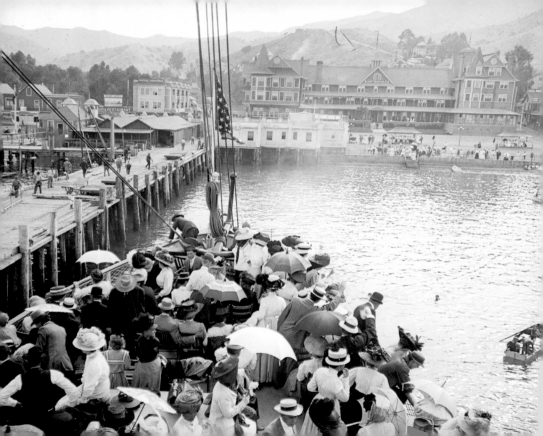

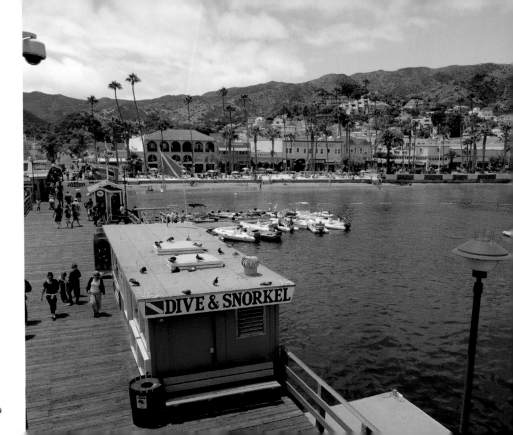

Avalon Pier, c. 1910

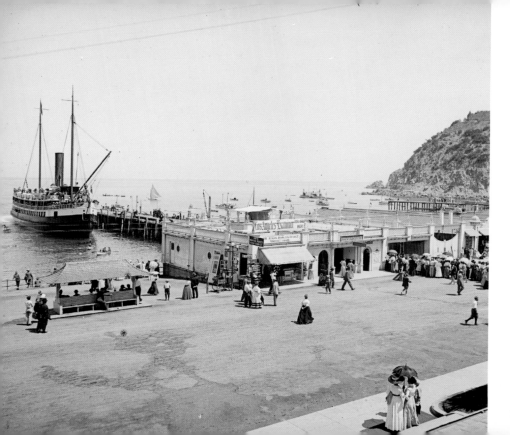

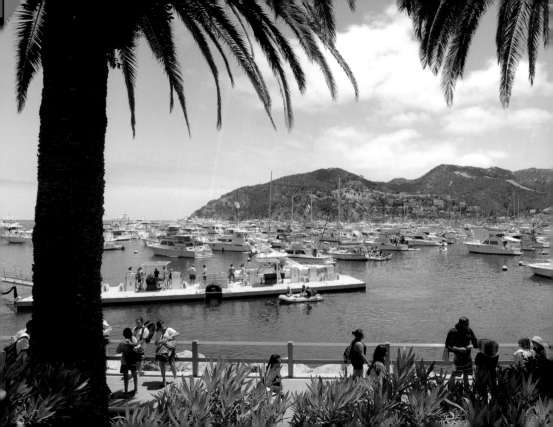

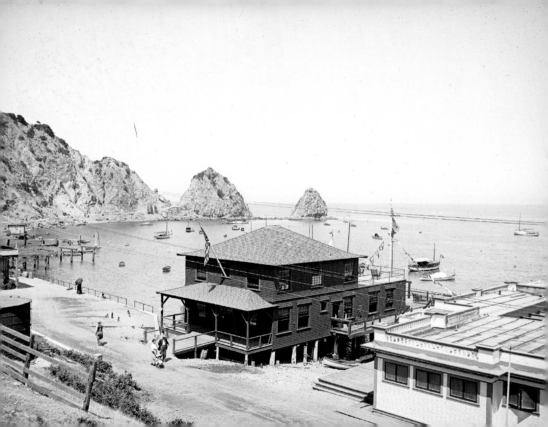

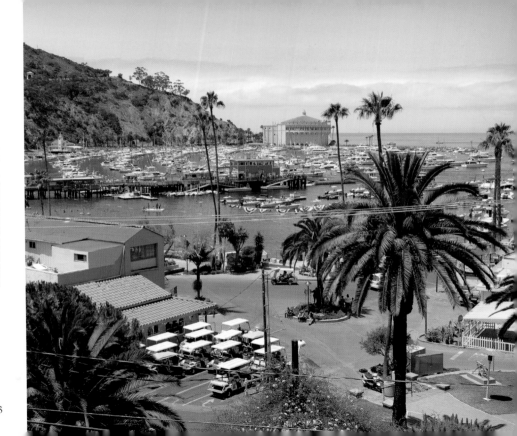

Tuna Club clubhouse, c. 1910

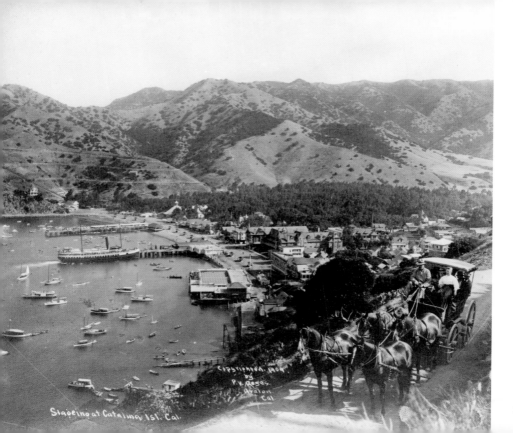

"Staging at Catalina Island," 1909

Staging at Catalina Isl. Cal.

Copyrighted, 1909
by
P.V. Reyes
Avalon
Cal.

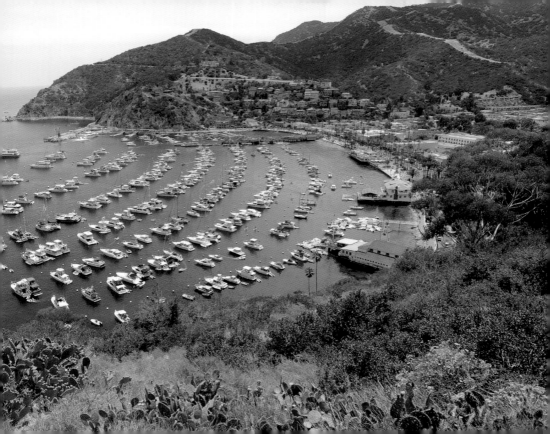

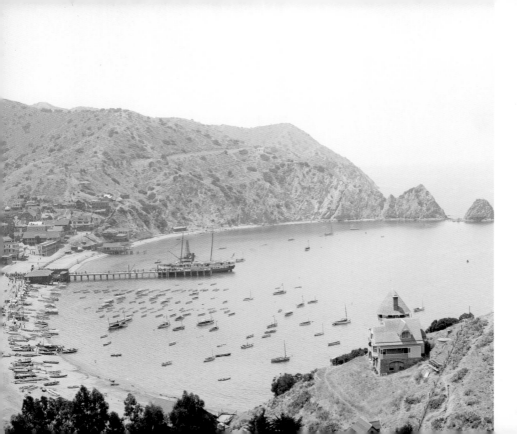

336

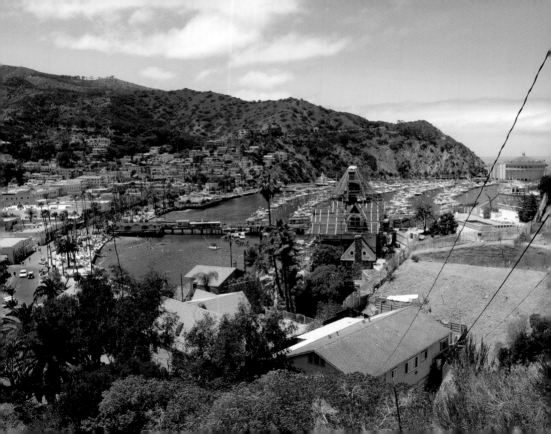

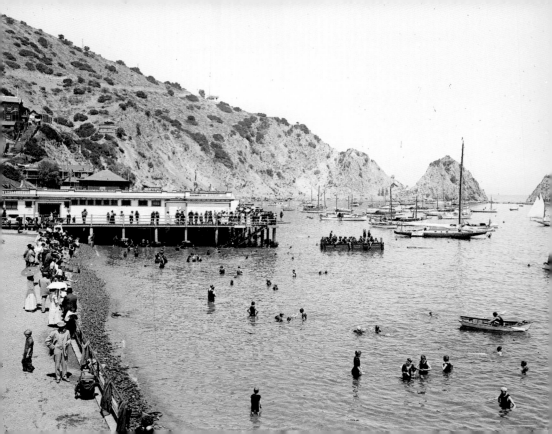

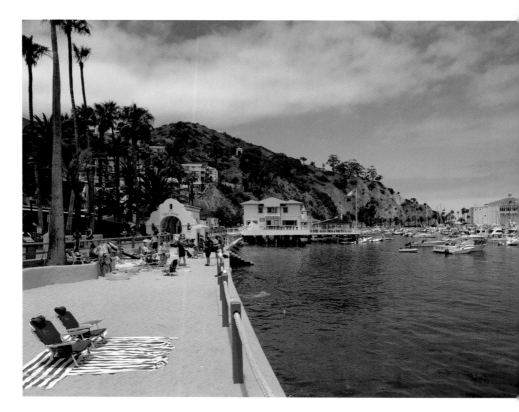

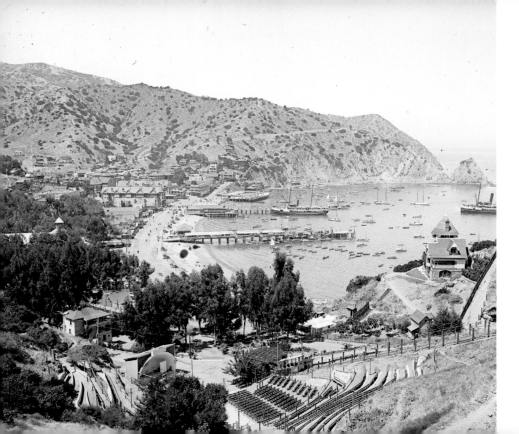

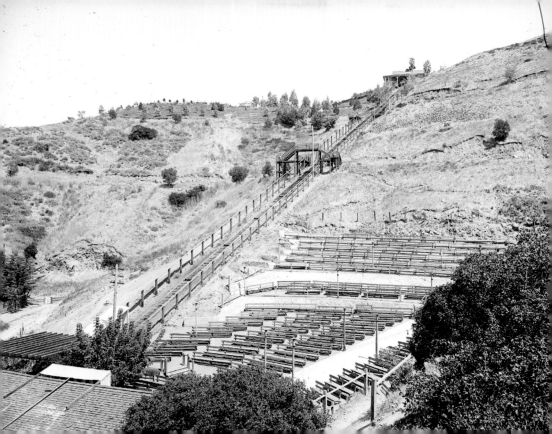

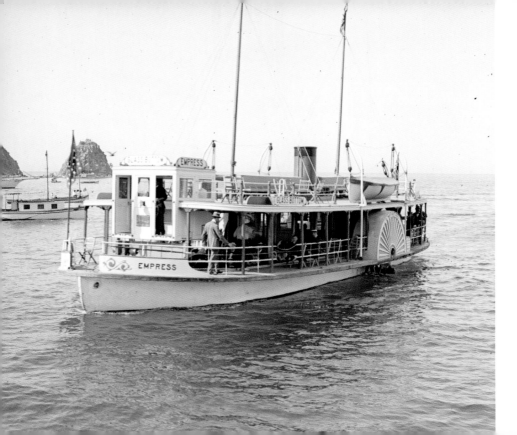

342

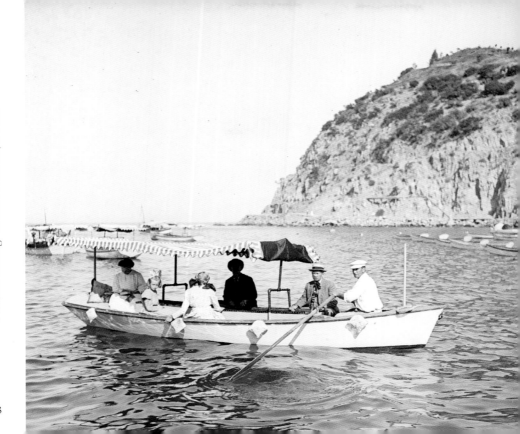

"Pleasure boating" in Avalon Harbor, c. 1910

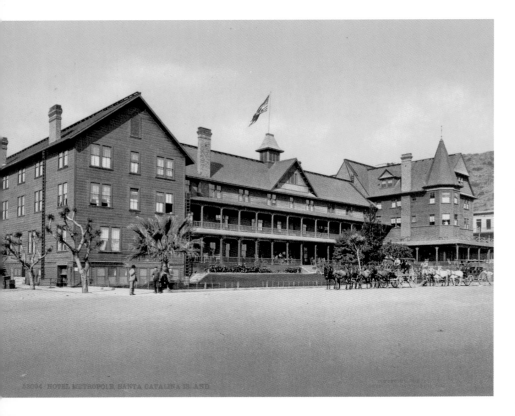

Hotel Metropole, Avalon, c. 1901

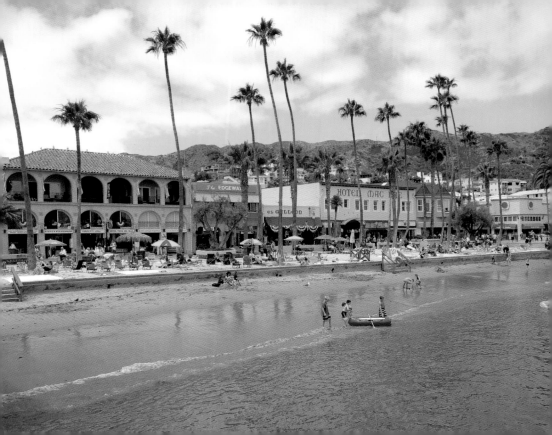

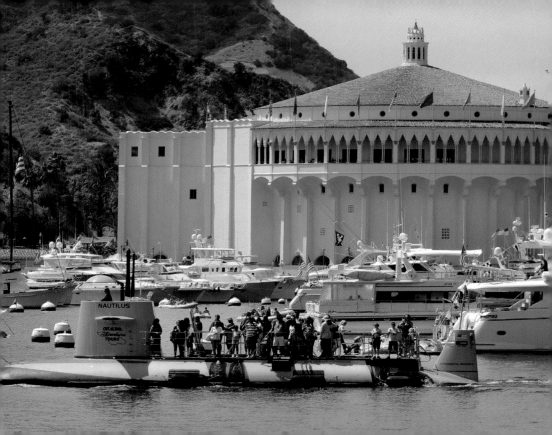

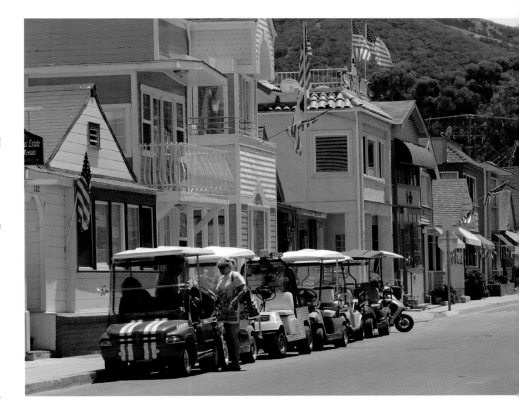

Pleasure submarining and electric buggies, Avalon

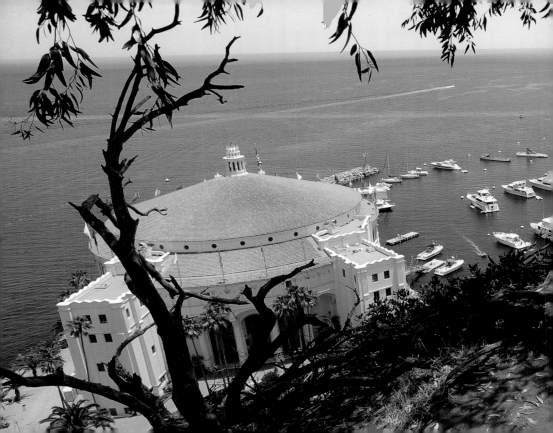

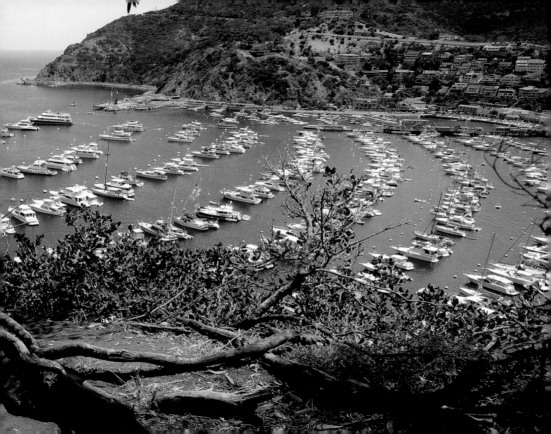

SAN

DIEGO

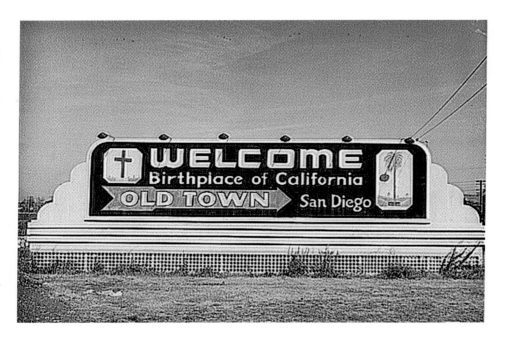

Old Town sign, San Diego, 1940

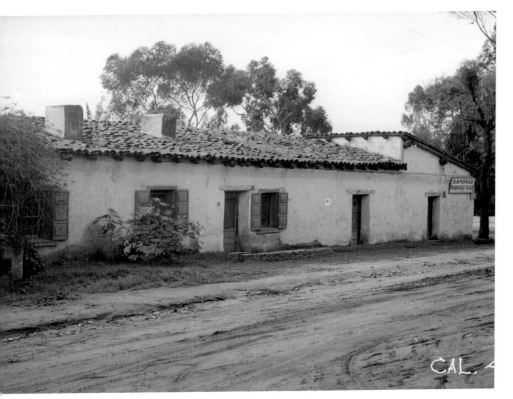

Jose Antonio Estudillo House, Old Town, San Diego, 1936

CAL. 4

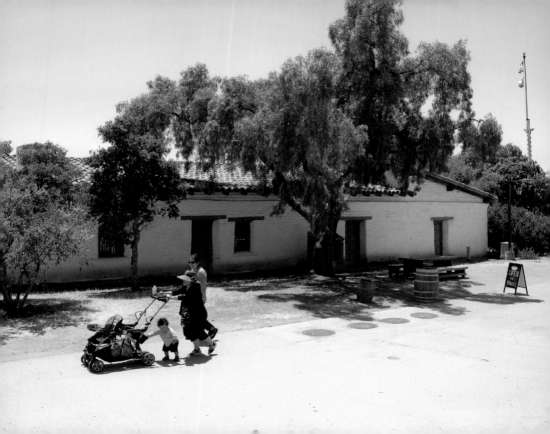

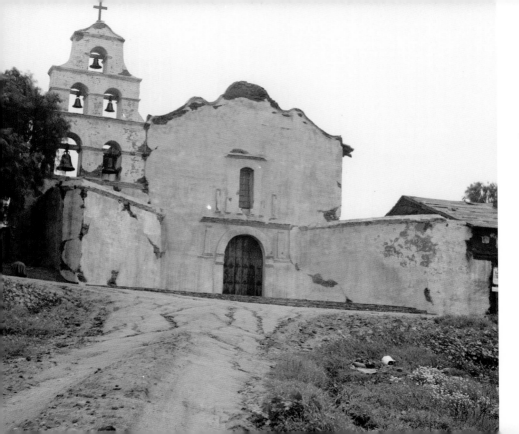

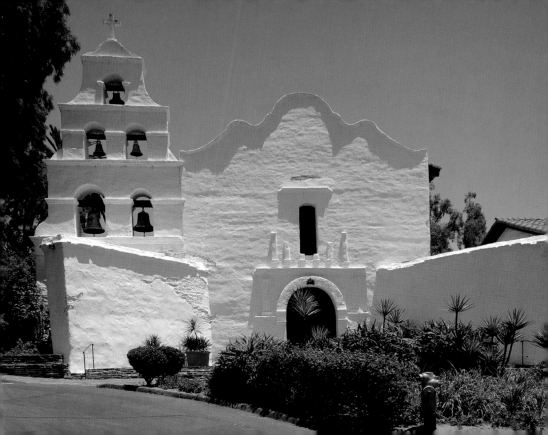

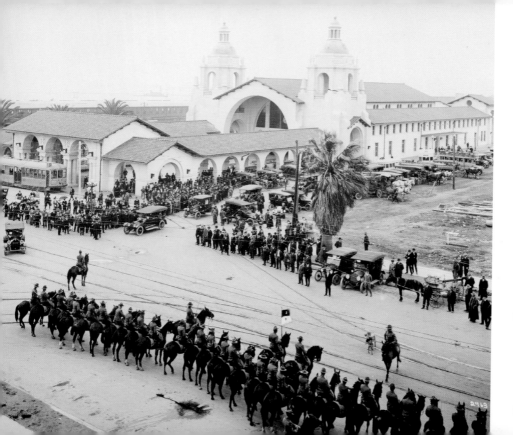

Santa Fe Railroad, Kettner Boulevard, San Diego, 1914

360

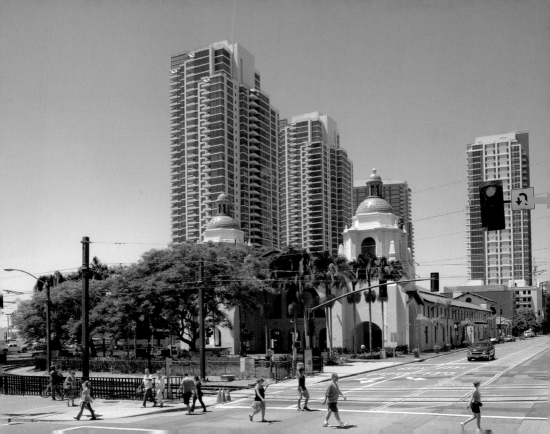

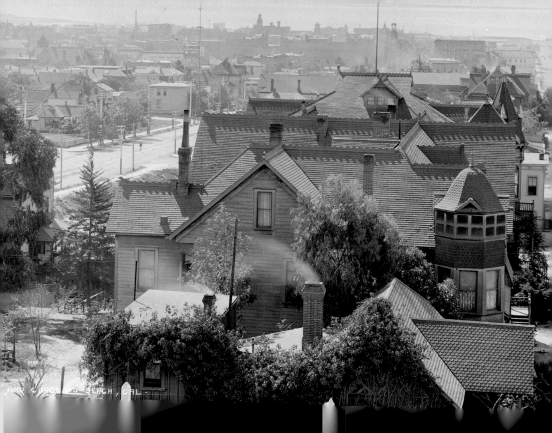

AND CORONADO BEACH, CAL.

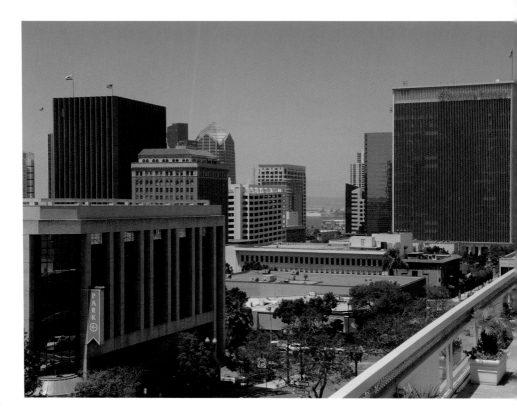

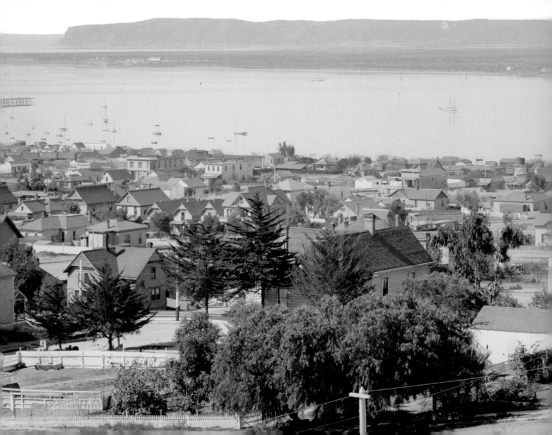

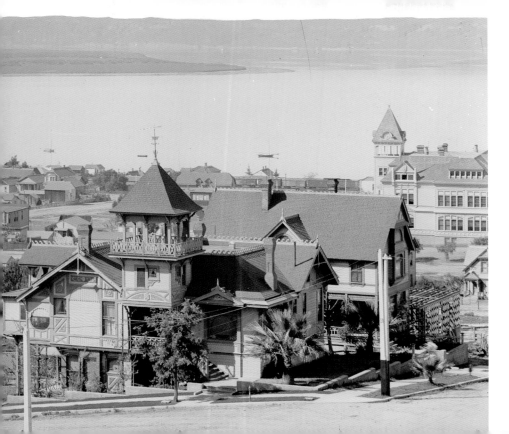

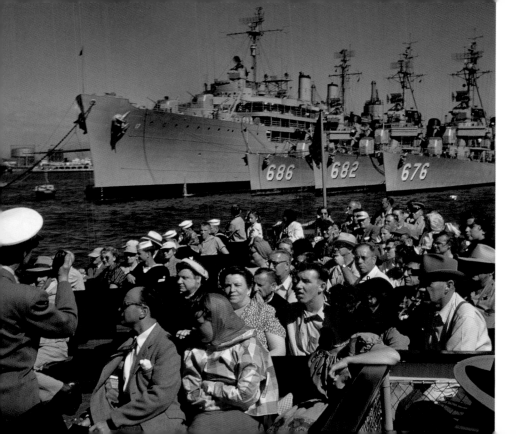

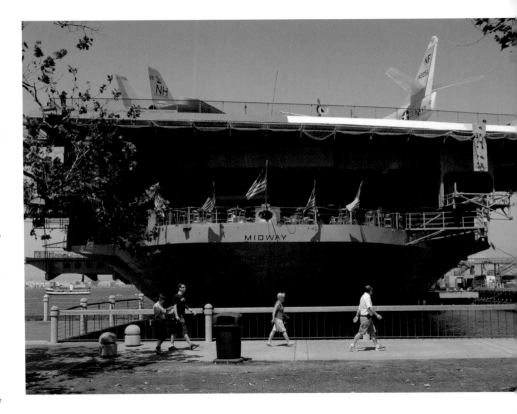

USS *Midway* Museum, San Diego

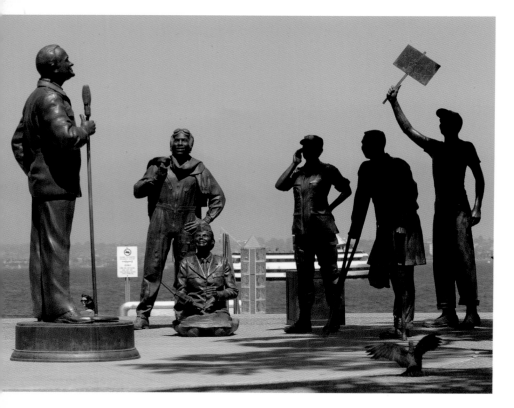

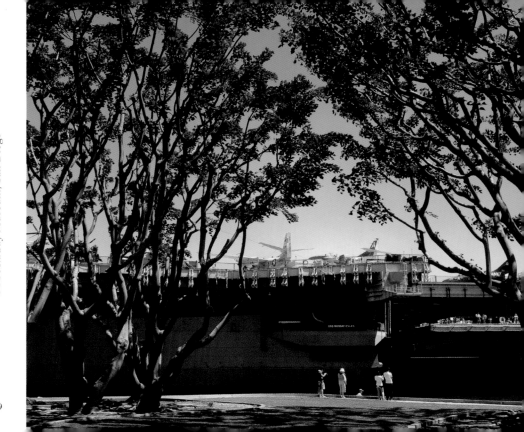

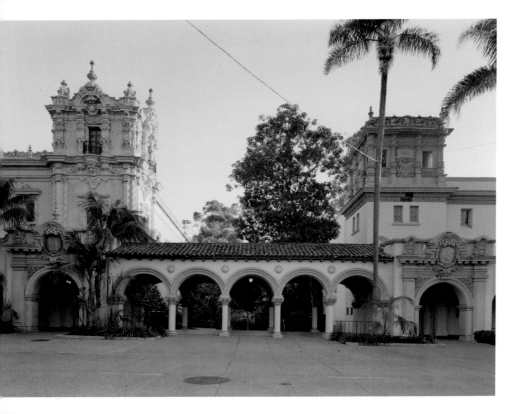

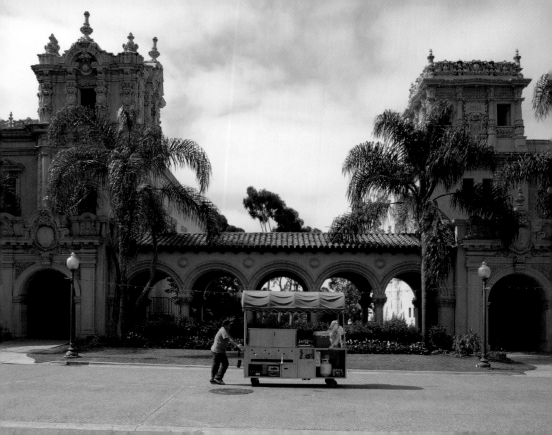

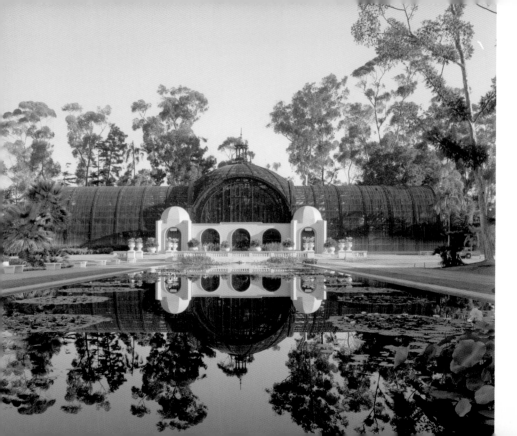

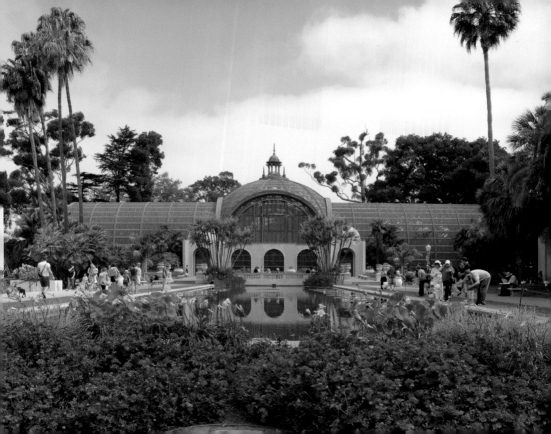

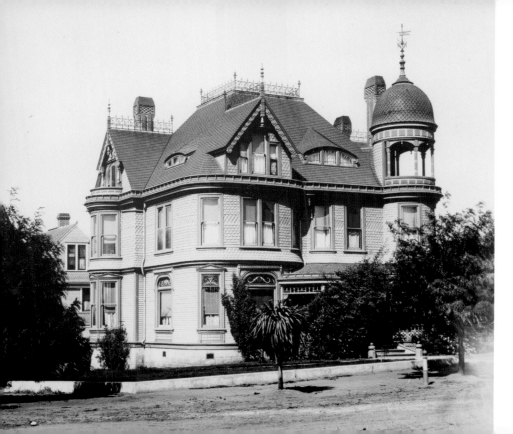

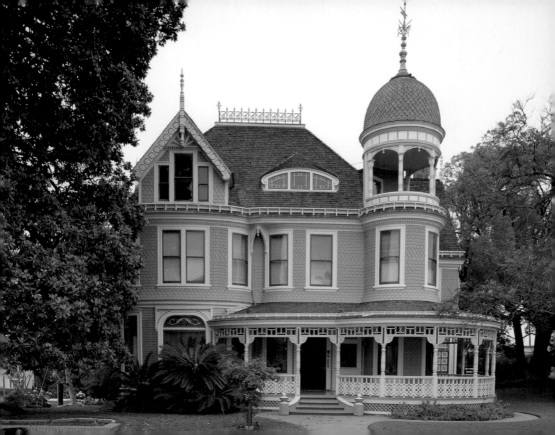

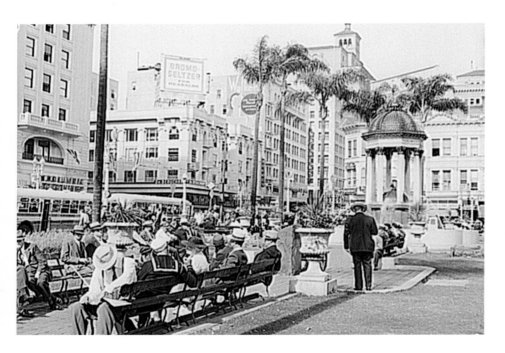

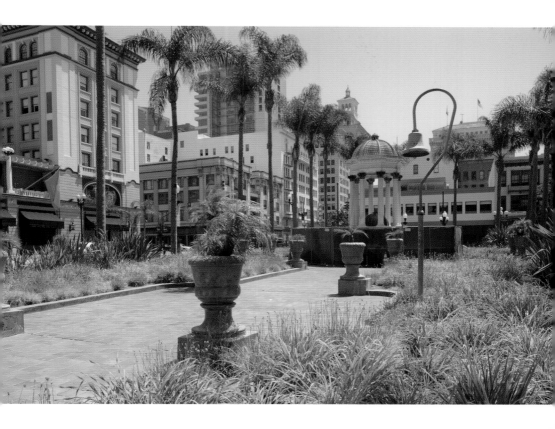

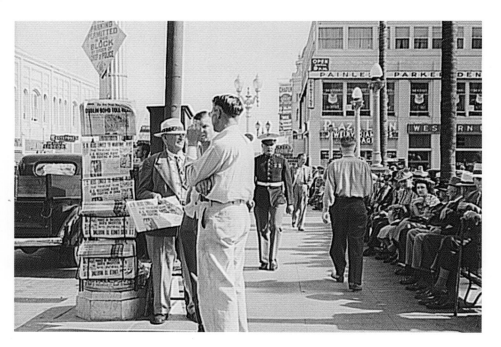

Sidewalk opposite the U.S. Grant Hotel, San Diego, 1941

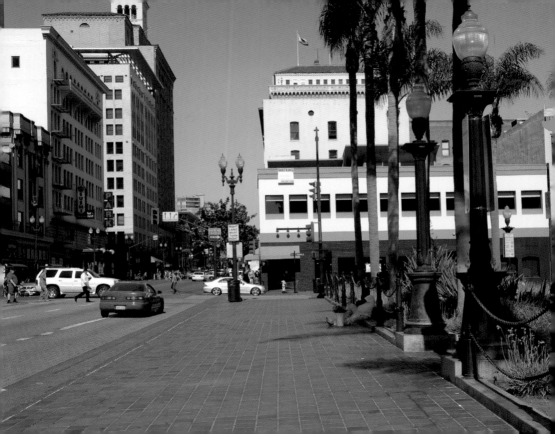

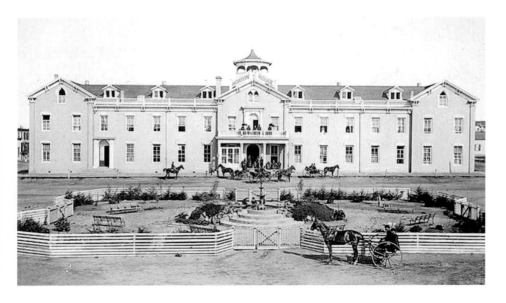

Horton House Hotel, San Diego, c. 1880

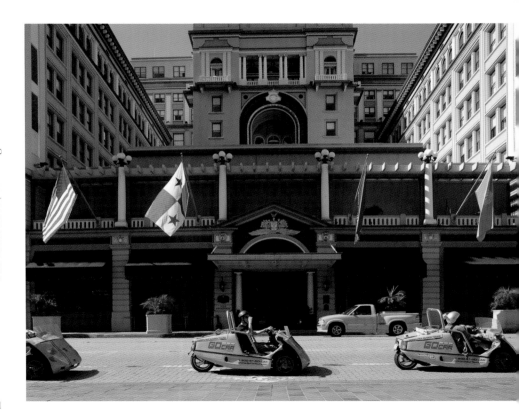

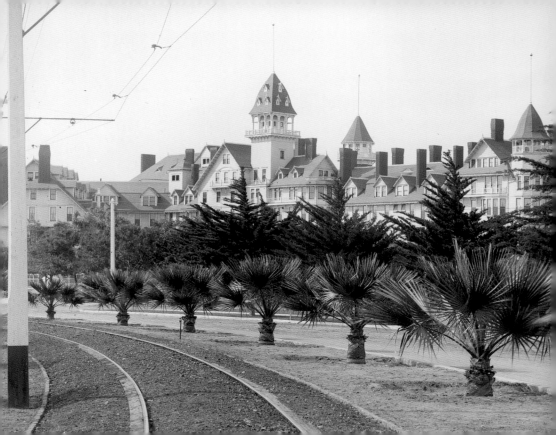

383

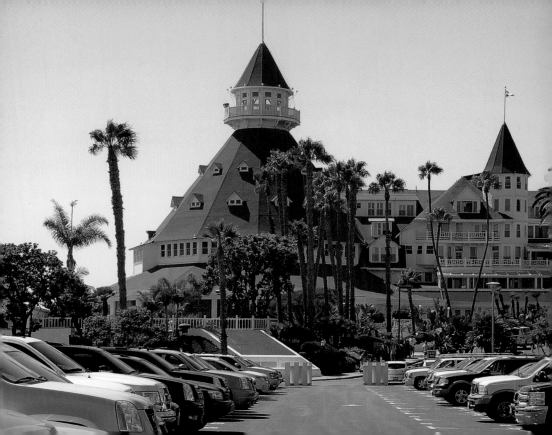

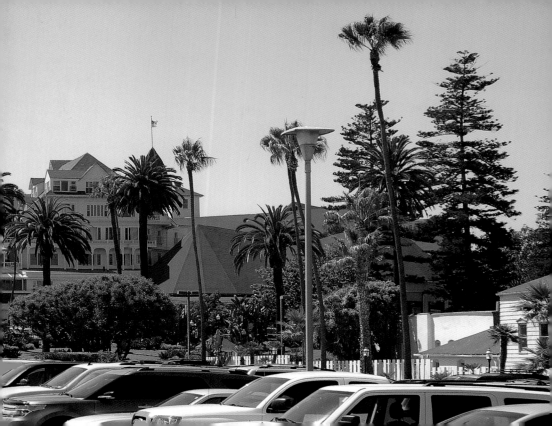

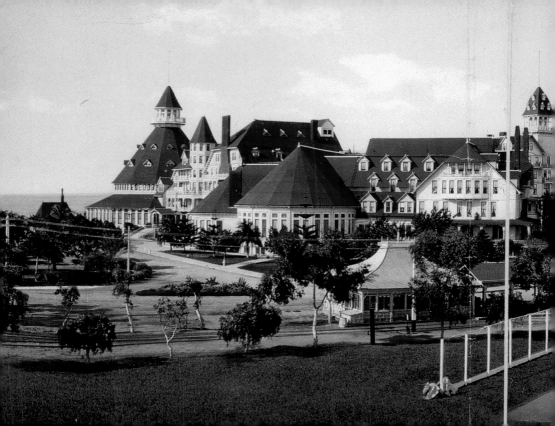

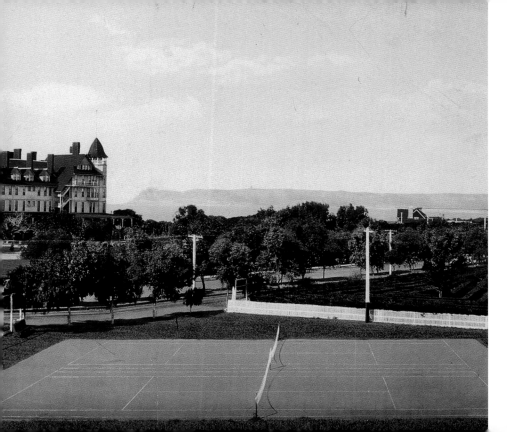

Hotel del Coronado, Coronado Beach, c. 1910

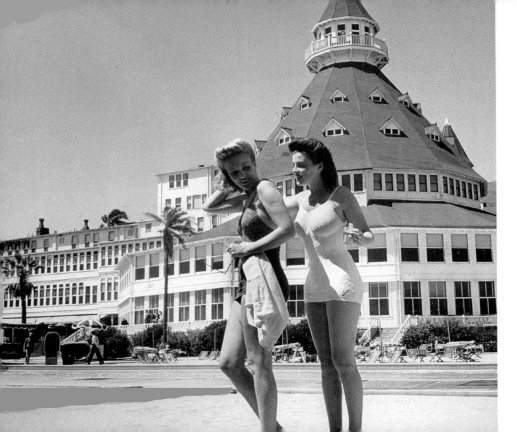

Hotel del Coronado, Coronado Beach, 1941

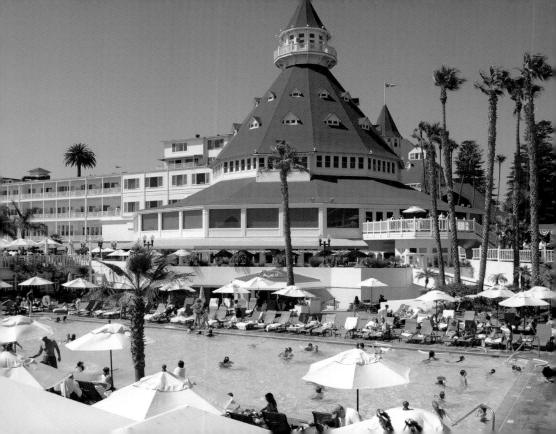

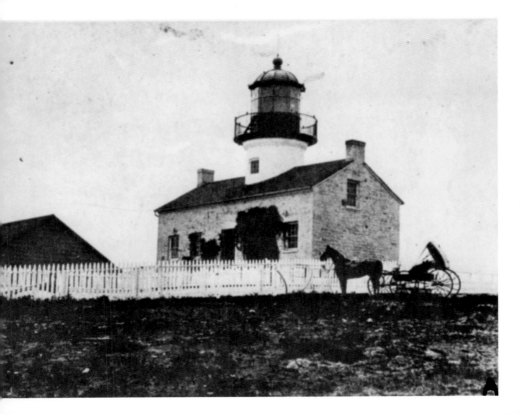

Point Loma Lighthouse, c. 1890

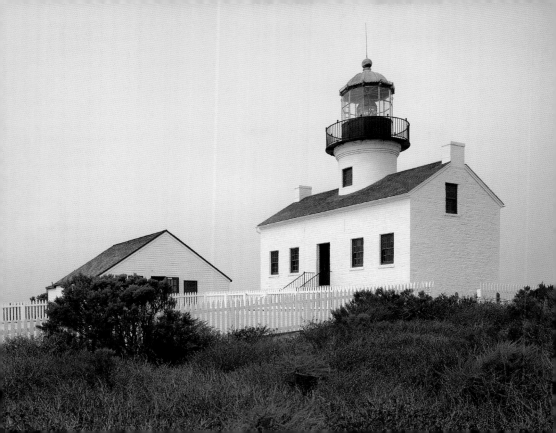

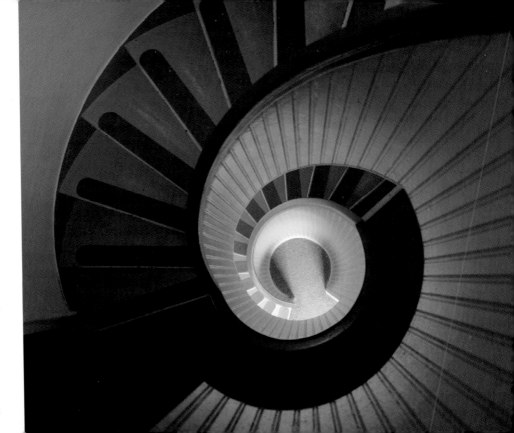

Spiral staircase, Point Loma Lighthouse

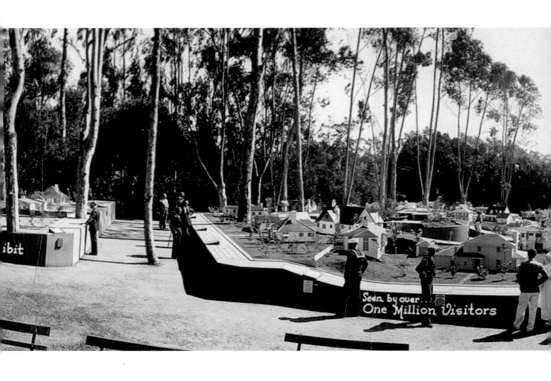

ibit

Seen by over...
One Million Visitors

Modeltown in Balboa Park, San Diego, 1935

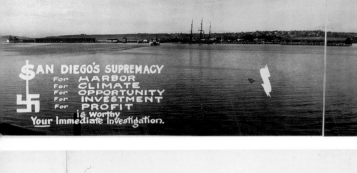

$SAN DIEGO'S SUPREMACY
For HARBOR
For CLIMATE
For OPPORTUNITY
For INVESTMENT
For PROFIT
IS Worthy
Your Immediate Investigation.

San Diego the Beautiful
"The View Poi~
WE PAY YOUR FARE. —— IF YOU

San Diego the Beautiful,
WE PAY YOUR FARE —— IF YOU BUY FROM US.

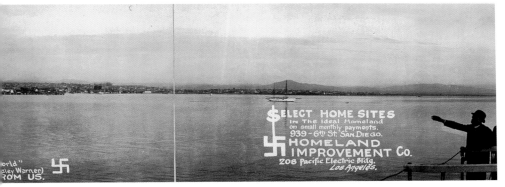

SELECT HOME SITES
In The Ideal Homeland
on small monthly payments.
939 - 6th St. San Diego.
HOMELAND
IMPROVEMENT CO.
208 Pacific Electric Bldg,
Los Angeles.

orld"
dley Warner)
ROM US.

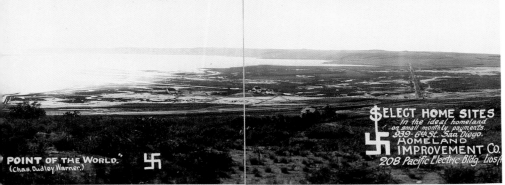

"POINT OF THE WORLD."
(Chas. Dudley Warner.)

SELECT HOME SITES
In the ideal homeland
on small monthly payments.
939 - 6th St. San Diego.
HOMELAND
IMPROVEMENT CO.
208 Pacific Electric Bldg. Lios A.